IMAGES
of America

KEARNEY

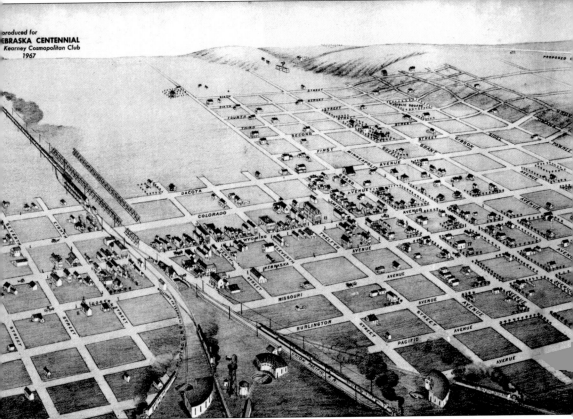

Kearney in the 1870s looked very different than it would just a decade later. While the layout of the town has remained fairly unchanged, the buildings and businesses that make up the very essence of the town have changed through the century. This map shows Kearney a few years after it was founded.

On the cover: Around 1900, throngs of spectators enjoy a parade on Central Avenue between Twenty-second and Twenty-first Streets. (Courtesy of the Buffalo County Historical Society.)

IMAGES
of America

KEARNEY

Mark R. Ellis and Heather E. Stauffer

ARCADIA
PUBLISHING

Published by Arcadia Publishing
Charleston SC, Chicago IL, Portsmouth NH, San Francisco CA

Printed in the United States of America

Library of Congress Catalog Card Number: 2006932272

For all general information contact Arcadia Publishing at:
Telephone 843-853-2070
Fax 843-853-0044
E-mail sales@arcadiapublishing.com
For customer service and orders:
Toll-Free 1-888-313-2665

Visit us on the Internet at www.arcadiapublishing.com

The book is dedicated to the many Buffalo County historians who preceded us and to those who will follow. Also, to Alfred T. Anderson and John Stryker, whose photographic legacies made this book possible.

CONTENTS

ACKNOWLEDGMENTS

The generous support of several people and institutions made this book possible. The majority of the photographs came from the archival collections of the Buffalo County Historical Society. Executive director Jennifer Murrish gave us unlimited access to the society's photograph collections. Photographs from the remarkable Alfred T. Anderson and John Stryker collections make up a significant part of the book's photographs. The University of Nebraska at Kearney also provided valuable assistance. Librarian and archivist John Lillis directed us toward dozens of never-before-published photographs housed in the Calvin T. Ryan Library. Ken Nikels, dean of graduate studies, and John Falconer, director of sponsored programs, provided funding for this project. Pam Proskocil provided her usual administrative assistance at different phases of the project.

Much of the research for this book was made possible by dozens of historians who have contributed to *Buffalo Tales* over the last 29 years. The work of Buffalo County historians Mardi Anderson, Samuel Clay Bassett, Gene Hamaker, Philip Holmgren, Alice Howell, Marian Johnson, Margaret Nielsen, and countless others paved the path for this book.

INTRODUCTION

In 1871, D. N. Smith and Asbury Collins, agents for the Burlington Railroad's land department, were given the task of locating the site where the Burlington would junction with the Union Pacific main line. Guided by Moses Sydenham, the trio left Fort Kearny after a late snowstorm in the spring of 1871 and crossed over to the north bank of the Platte River. The agents were careful not to locate the junction point directly north of the fort because that land was still part of the Fort Kearny Military Reservation and thus off-limits to settlers. Instead, the group traveled several miles up the river where they located a section of land on a broad plain nestled between the Platte River and gently rising hills. At this location, on April 11, 1871, what would later become the city of Kearney was selected as the junction point for the two railroads.

Kearney is situated in the Platte River valley in south-central Nebraska. Named after nearby Fort Kearny, the city has an extra *e* in its name due to a clerical error at the post office. By the time the mistake was discovered, nobody cared and the name stuck. In 2006, Kearney has a population of just under 30,000 people. The city is an important commercial, medical, education, and tourist center in central Nebraska. It is the home to two state institutions: the Youth Rehabilitation and Treatment Center began working with Nebraska's wayward youths in 1881, while the University of Nebraska at Kearney first offered courses in 1905.

Kearney's historical past is closely connected to many of the popular events and images of the American frontier. The region was once part of the prized hunting grounds of Plains Indians tribes such as the Pawnees and Lakotas. Famed frontier explorers such as Stephen Long and John Fremont traveled through and mapped the region during the first half of the 19th century. Soldiers at Fort Kearny guarded travelers on the Oregon and Mormon Trails while the pony express, during its brief life, skirted through what became Buffalo County. During the mid-1870s, Kearney's citizens battled Texas cowboys in what was known as the Kearney War. Kearney was born because of the railroad and during its first 50 years was very much a railroad town. Kearney, however, was unique in that it was not dominated by a single railroad. Because the Union Pacific and Burlington lines both competed in Kearney, the citizens of the city were allowed to develop a unique community unencumbered by the corporate power of the railroads.

With the dawning of the automotive age, Kearney drifted away from its railroad roots and found a new beginning on America's highways. Kearney was one of the first communities to pave its portion of the transcontinental Lincoln Highway that bisected town. The city even began marketing itself as the "Midway City" to attract automobile travelers. Motels, service stations, diners, and a variety of tourist traps dotted the highway through Kearney and its surrounding towns. Today Kearney sits on Interstate 80, and the Archway Monument, a museum that celebrates the region's history and people, arches over the roadway. While Kearney has been attracting tourists for more than 100 years, the region in and around the city also attracts the magnificent sandhill cranes on their spring migration toward Canada. These endangered birds, along with millions of other waterfowl, use the fields and river valley around Kearney to gain strength to complete their yearly migration.

The location of Kearney is only half the reason for its success. The other factor in the growth of Kearney has been the people who have called this city on the Great Plains home. Early 19th-century settlers such as Frank Hamer and Norris Brown, for example, promoted their community and gained fame in law and politics at the state and national level. Brown represented Nebraska in the U.S. Senate, and Hamer went on to serve on the Nebraska Supreme Court after a 40-year legal career. The George Frank family, who moved to the region in the 1880s, was responsible for bringing electric power to the city. They wined and dined hundreds of eastern investors at their ornate mansion that is now part of the campus at the University of Nebraska at Kearney. H. D. Watson introduced alfalfa to the area and built the world's largest barn in the 1900s. While these men were certainly innovative promoters of Kearney, it was the thousands of unknown homesteaders and businessmen who carved out a living that made Kearney a successful city. The famous and the unknown, therefore, have helped make Kearney what it is today.

This book will highlight Kearney's colorful historical past through unique, never-before-published photographs and interpretive captions that help explain how Kearney evolved into a premier Great Plains community. Kearney is unique in that it is one of the few Nebraska communities that has continued to grow in population and expand its economy over the past century. During the late 1880s and early 1890s, Kearney was the place to be, and entrepreneurs from across the nation moved to and invested in the city. As a result, the city's early history was thoroughly documented by local photographers such as Alfred T. Anderson, John Stryker, and Solomon Butcher. The Anderson collection of high-quality photographs recorded Kearney's economic boom years during the late 1880s and early 1890s. Photographs in this collection include downtown businesses, the upscale Kenwood neighborhood, the Buffalo County Courthouse, the Opera House, and the Midway Hotel. John Stryker snapped photographs of the university, public schools, street scenes, and town celebrations in the years around 1920. Today the Anderson and Stryker collections, along with hundreds of other photographs, are owned by the Buffalo County Historical Society and are used to illustrate the county's rich and fascinating history. Due to copyright issues, Butcher photographs do not appear in this book. Unless otherwise noted, all photographs were provided courtesy of the Buffalo County Historical Society.

This is not a comprehensive history of Kearney. For a thorough discussion of Kearney's early history one should consult Samuel Clay Bassett's monumental two-volume book, *Buffalo County, Nebraska and Its People*. Another useful source is *Buffalo Tales*, the Buffalo County Historical Society's bimonthly publication. First published in 1978, *Buffalo Tales* articles were a valuable resource in writing this book. What this book provides, however, is a visual glimpse into Kearney's rich historical past, particularly the years 1890 to 1945. While the authors made an effort to cover Kearney's entire history, the existing photographic record is limited. Very few photographs exist of the pre-1890 period, and, surprisingly, few photographs of the post-1950s period have found their way into archival collections. By circumstance, the 1890s are heavily represented due to the incredible photographic collection of Alfred T. Anderson. The second and third decades of the 20th century were captured by John Stryker, a college professor turned photographer. Thus, it is no mistake that these time periods are thoroughly covered in this book. If photographers from the 1880s or 1930s had donated their photographic collections, a more complete visual history of Kearney's past would exist. This should serve as a lesson to those who have community photographs hidden away in drawers, boxes, and attics. Donate them to a local historical society for all to enjoy!

One

MAIN STREET KEARNEY

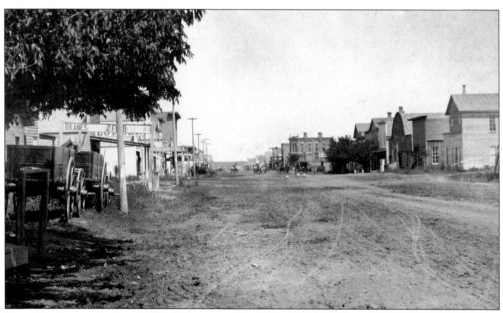

Kearney was in many ways still a frontier community during the early 1880s when this photograph was taken. False-front buildings, dirt streets, and livestock in the middle of Central Avenue (or Wyoming Avenue, as it was known until the late 1880s) were commonplace. This rare view of Central Avenue was taken from the south side of the railroad tracks near present-day Nineteenth Street. While banks, general goods stores, and office buildings began appearing on the north side of the tracks, south Kearney was reserved for lumberyards, livery barns, flour mills, blacksmith shops, and boardinghouses. The ornate building in the center of the photograph is the Lowe Building. Constructed in 1881, this building still sits at the corner of Central Avenue and Railroad Street.

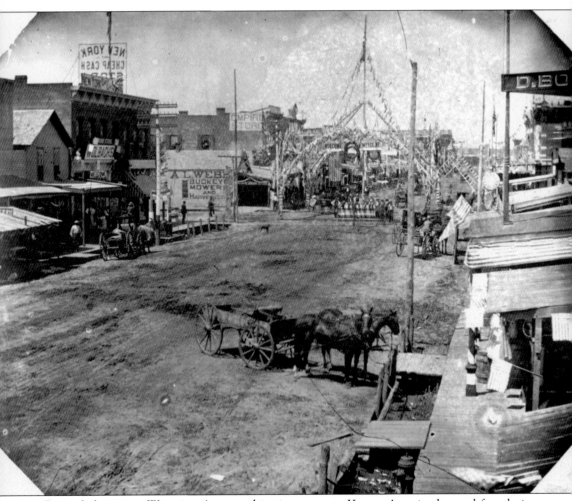

Formerly known as Wyoming Avenue, this view captures Kearney's main thoroughfare during the mid- to late 1880s. Prominent businesses on the west side of the street include the New York store, A. L. Webb's farm implements, and Empire general merchandise store. The Welcome banners in the middle of the intersection of modern-day Central Avenue and Twenty-first Street may have been for a fireman's competition that Kearney hosted in July 1887. Fire ladders can be seen in decorations on either side of the stage in the middle of the photograph, and several firemen are standing next to the stage. Teams came from as far away as Amsterdam, New York, to compete against Kearney's championship hose cart team.

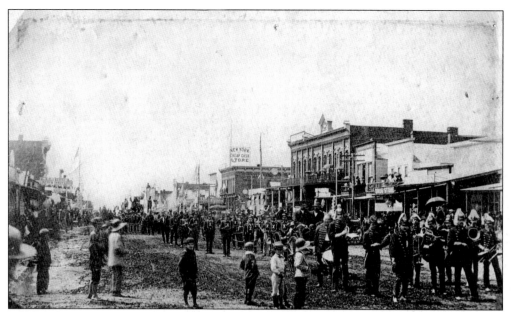

Parades were an important part of community life during the 19th century. These two photographs were taken during the 1880s. The photograph above depicts a muddy Central Avenue between modern-day Twenty-second and Twenty-first Streets. Heading the parade is probably the Kearney Coronet Band, while following behind appears to be the volunteer fire department. In the photograph below, a local band poses for a picture in the middle of Central Avenue on the south side of the tracks.

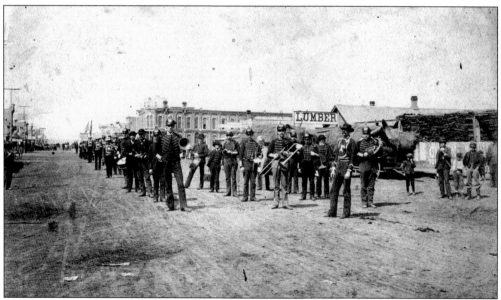

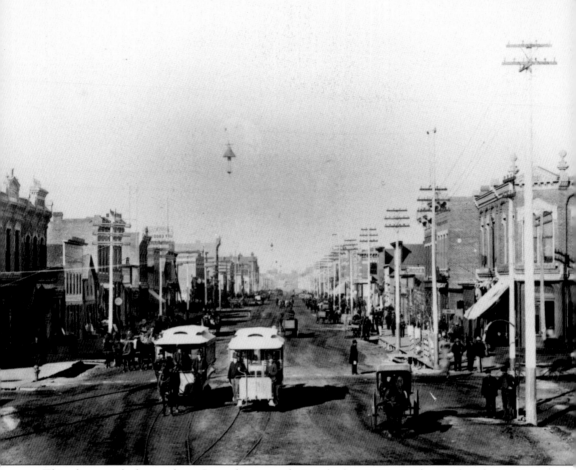

This photograph shows a busy Central Avenue during the late 1880s. Evidence of modernization can be seen in the power lines, streetlights, water hydrants, and streetcars. Horse-drawn streetcars appeared in the late 1880s and ran north to south from modern-day Twenty-fifth Street to the Buffalo County Courthouse. By the early 1890s, electric streetcars replaced the horse-drawn cars.

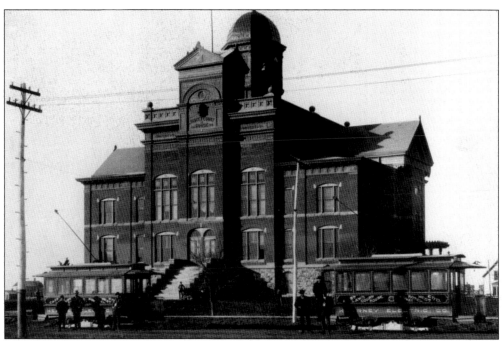

The Kearney Electric Company's streetcars ran from north to south, connecting the courthouse to the luxurious Midway Hotel via Central Avenue. Another line ran from west to east and connected the newer communities of West Kearney and East Lawn by way of Twenty-fifth Street. The Midway Hotel stood at the north end of the Central Avenue business district. The Midway was Kearney's upscale hotel. Visitors to town arrived at the Midway by riding a streetcar from the train depots at Central Avenue and Railroad Street northward to the hotel. This view is looking west down Twenty-fifth Street toward Central Avenue.

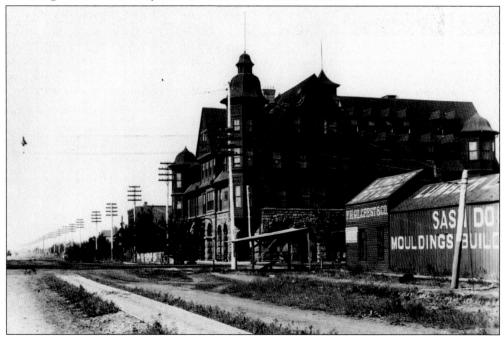

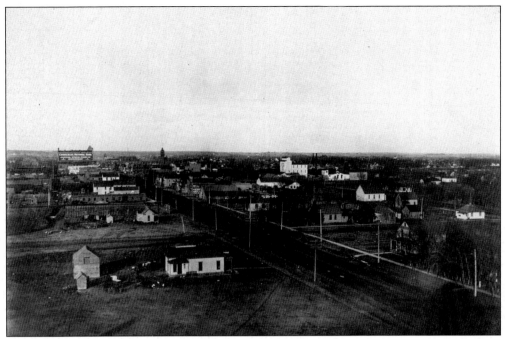

Few photographs exist of south Central Avenue. This photograph was taken from the dome of the Buffalo County Courthouse, probably around 1900. The taller buildings along the skyline include, from left to right, the Opera House, city hall, and the flour mill.

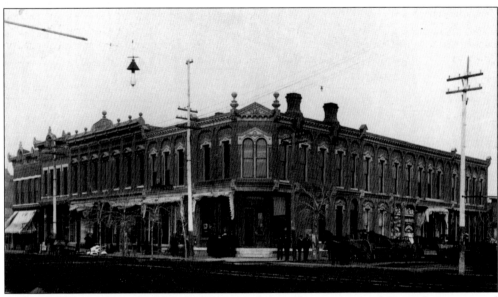

Built in 1881, the Lowe Building still sits on the northeast corner of Central Avenue and Railroad Street. It has been the home to a host of businesses, including the Farmer's Bank when this photograph was taken in the early 1890s.

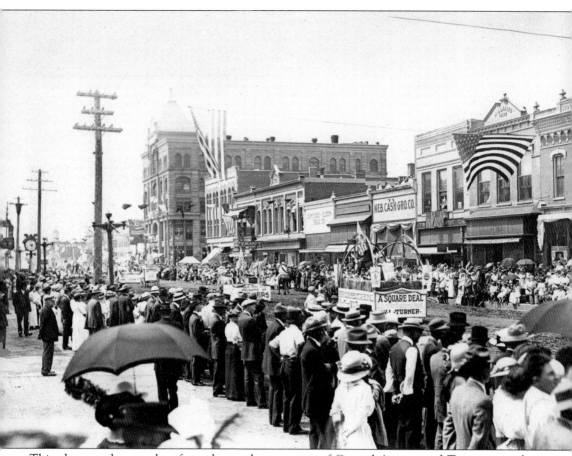

This photograph was taken from the southeast corner of Central Avenue and Twenty-second Street. Hundreds of Kearney residents, both young and old, enjoy a southward marching parade, probably during the early years of the 20th century. This photograph reflects a thriving downtown. The ornate Opera House stands like a monument in the background.

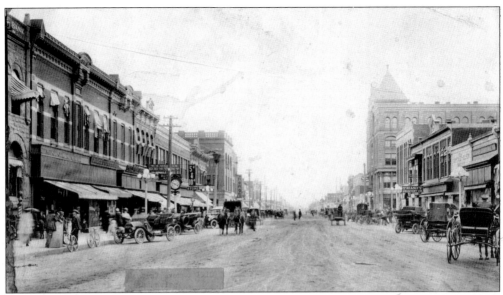

Early in the second decade of the 20th century, a variety of businesses operated on the block between Twenty-first and Twenty-second Streets, including three drugstores, a dentist, a bank, a grocery, a barber, a clothier, a five-and-dime store, and even a garage. By the middle of the decade, automobiles could be seen on downtown streets, but the horse and buggy was still the primary mode of transportation. The Opera House is visible on the right, while the City National Bank sits across the street.

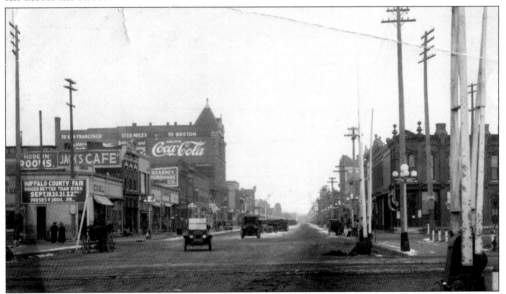

Taken several years after the photograph above, this view of Central Avenue suggests that the automobile was beginning to supplant horsepower as the preferred mode of transportation. Visible are two horse and buggies, but automobiles dominate the downtown. Gone are the streetcars, which had disappeared after a short life span during the 1890s. A host of businesses lined the street between Railroad and Twenty-first Streets, including a coal business, Jack's Café and Boarding House, an ice-cream parlor, and Kearney Hardware. The imposing structure on the left is the Opera House, which was still hosting memorable performances during the second decade of the 20th century.

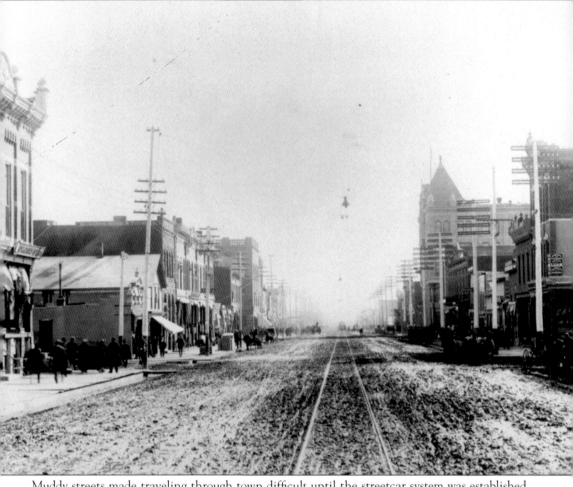

Muddy streets made traveling through town difficult until the streetcar system was established during the late 1880s. The raised wooden sidewalks provided some relief from the grime, but to cross from street to street pedestrians had to get their shoes dirty. With the appearance of automobiles on Kearney's streets after 1900 paving became a necessity.

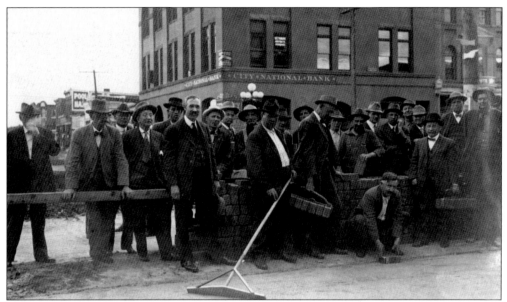

Muddy streets were not conducive to automobile transportation, and thus, the city moved toward paving the downtown during the second decade of the 20th century. Beginning in 1915, workers began grading and laying bricks on downtown streets. In this photograph, public dignitaries are laying the first bricks at the intersection of Central Avenue and Twenty-first Street, directly in front of the Opera House. Notice that only one laborer, a man in overalls with a brick in his hand, is visible in this ceremonial photograph.

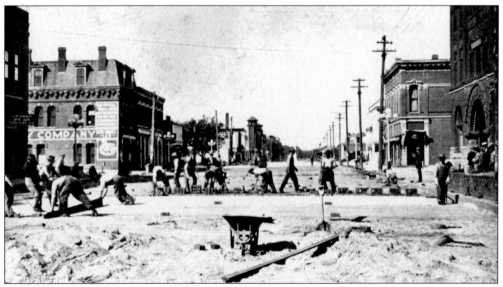

In the photograph above, laborers are grading and laying bricks on Central Avenue between Twenty-second and Twenty-third Streets. Prominent buildings in the picture include the Midway Hotel in the center and the Federal Annex building on the right side. The building on the left with the two chimneys dates to the 1870s and is one of the oldest structures in Kearney.

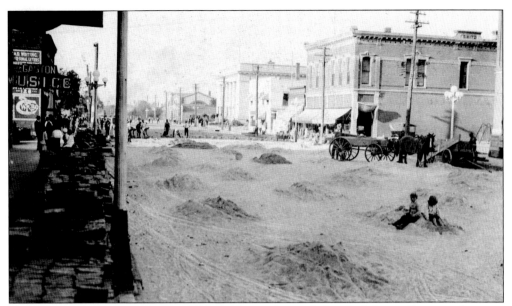

In the photograph above, young children play in the sand ahead of the grading crew between Twenty-second and Twenty-third Streets. The post office, now the Museum of Nebraska Art (MONA), is visible in the background.

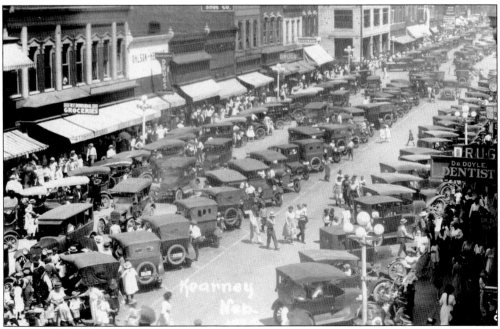

This picture depicts a busy downtown Kearney during the early 1920s. Gone are all vestiges of the horse-and-buggy days. The streets are paved and lit with lamps, and many people seem to own automobiles. This was probably taken on a Saturday afternoon as that was when families came to town for shopping and entertainment.

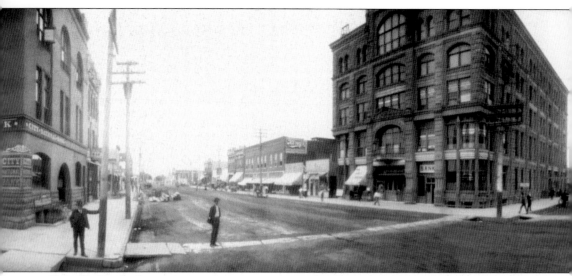

Described as the "most imposing structure . . . outside of Lincoln and Omaha," the Opera House was built in 1891 at a cost of $140,000. Constructed of Rawlins gray stone, the Opera House covered three downtown lots and stood five stories high. The building was heated by steam, lit by electricity, and reportedly had perfect acoustics. During its heyday, the Opera House witnessed performances and speeches from notables such as William Jennings Bryan, Buffalo Bill Cody, Harry Houdini, John Philip Sousa, Lionel Barrymore, Carrie Nation, and George Cohen.

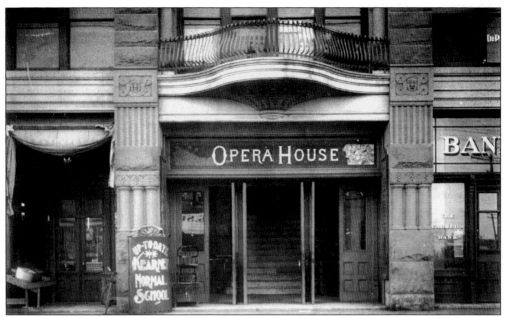

The Opera House building was much more than a place of entertainment. It housed a variety of different businesses, including the Kearney National Bank, a department store, a billiards hall, a saloon, a dentist, a doctor, and lawyers. Bands often performed from the balcony above the entrance. As the largest building in town, the Opera House also served as a community center. High school and college graduations were held in the building. The carved stones on the columns next to the entrance now sit on the grounds of the Trails and Rails Museum.

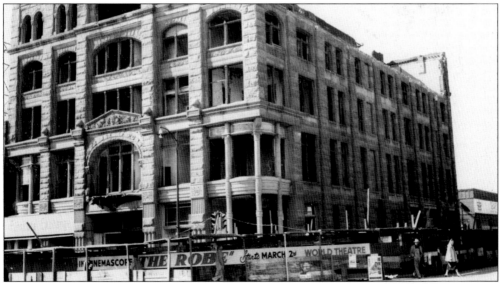

The Opera House stood on the southwest corner of Central Avenue and Twenty-first Street from 1891 to 1954. The popularity of movies during the 1920s doomed the Opera House as an entertainment venue. The last stage performance took place during the throes of the Great Depression on May 14, 1932. Ironically, an advertisement for the World movie theater decorates the front of the work zone as the building is being dismantled in 1954. Today a less impressive structure sits where Kearney's most imposing landmark once sat.

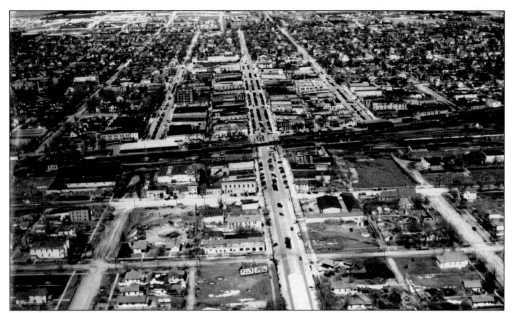

This aerial view of downtown Kearney indicates the importance of Central Avenue before the 1960s. The Second Avenue viaduct has not been built, and Central Avenue is the only downtown street that crosses over the railroad tracks. Cars are parked on both sides of the street, and a look down the center strip reflects a downtown thriving with business. Note that the Opera House is now gone, but the Fort Kearney Hotel still stands on the northeast corner of First Avenue and Twenty-first Street, and the Midway Hotel is on the northwest corner of Central Avenue and Twenty-fifth Street. The northern edge of the city does not extend much farther than Thirty-first Street.

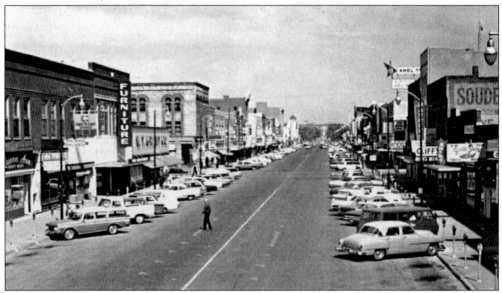

By the mid-1960s, Central Avenue began to look tired. The Opera House was gone, replaced by the low-level building on the left side of the photograph. Oil-stained streets and run-down-looking buildings dominate the once bustling thoroughfare. The trees that line Central Avenue in 2006 have not yet been planted.

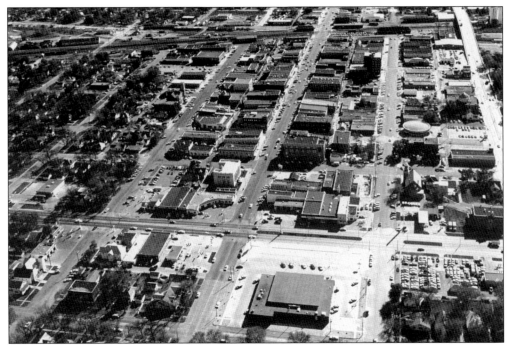

This south-facing aerial view depicts a downtown in transition. Constructed in 1962 to provide access to the newly built Interstate 80, the Second Avenue overpass, seen in the upper right corner, funneled traffic away from Central Avenue. Parking is no longer needed in the middle strip. The old Methodist church is still standing at the corner of Avenue A and Twenty-second Street, although fire will claim it in 1969. The Union Pacific and Burlington depots still sit along the tracks at the top of the photograph, but both disappeared shortly after this photograph was taken. Gone is the Midway Hotel, replaced by a supermarket and a huge parking lot at the bottom center of photograph. The Soldiers Monument that now resides in the MONA parking lot still stands in the median strip of Highway 30.

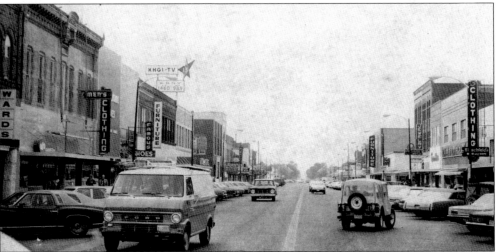

A decade later, not much has changed in the 1970s. Downtown still looks a little worn-out. With the opening of the Second Avenue overpass, and greater access to large retailers, Central Avenue's many businesses moved to other locations.

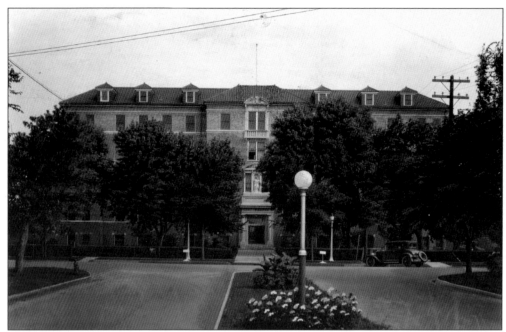

Good Samaritan Hospital, operating under the direction of the Catholic Church, opened on July 23, 1924. The original building sits at the head of Central Avenue and looks toward downtown. Since this photograph was taken in the late 1920s, the hospital has gone through numerous expansions. In 2006, Good Samaritan serves as the medical center for much of central Nebraska.

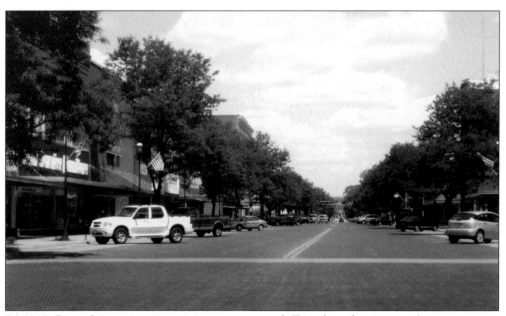

By 2006, Central Avenue was experiencing a renewal. Trees line the street and cover up some of the aging buildings. The bricks at Central Avenue intersections between Twenty-first and Twenty-fourth Streets were pulled up and the surface evened out. Traveling Main Street by automobile became much smoother after this fix. The downtown has also seen the addition of new consumer-based businesses such as Baristas, the Roman, and Thunderhead Brewing.

Two

BOOM AND BUST

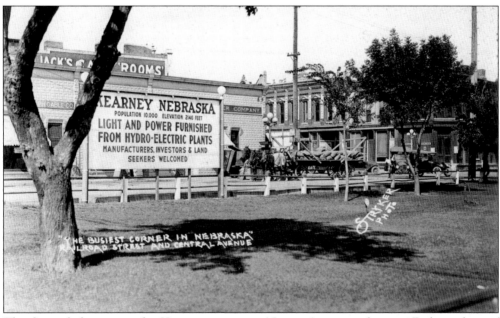

The first inhabitants in the Kearney area were Native American farmers. Early settlers, of European descent, also farmed on the plains in the late 1800s. The establishment of railroads and towns over the latter part of the century and into the 1900s led to increasing business and industry opportunities, which have been affecting Kearney ever since.

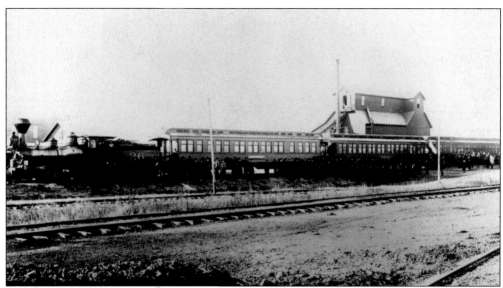

Investors from eastern states were brought to Kearney by the trainload during the late 1880s and early 1890s by businessmen such as George Frank, who established the Kearney Improvement Company, which helped with many town improvements. Additions and improvements to the town included work on the Kearney Canal to provide water and electrical power to town, Kearney Cotton Mill, and wool, paper, and oatmeal mills, as well as many factories. Visiting investors stayed at the Midway Hotel, which was known as Kearney's social center at the time, and some were invited to the Frank mansion. Built by George Frank during the boom, this was the largest residence in Kearney. The house was made with materials from Colorado, the tile roof was imported from Holland, and a Tiffany window came from New York.

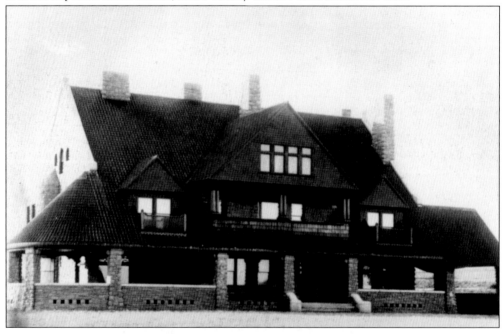

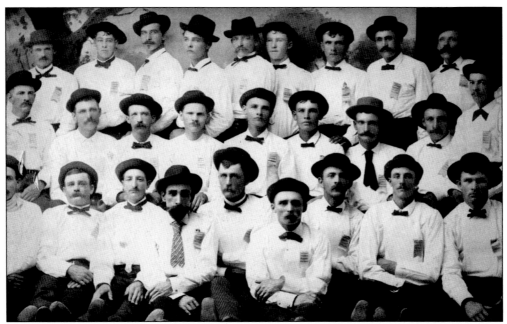

The Kearney boom began in the mid-1880s, with the construction of the canal and availability of electricity. In 1889 alone, the city gained 3,000 people, raising the population to 12,000. Railroad business increased 100 percent, banking nearly doubled, and over $1 million was spent on new buildings. New industries were started, new neighborhoods were developed, such as Kenwood, East Lawn, and West Kearney, and new downtown businesses were doing well. The cartoon below shows the optimism of local residents and investors for the ever-expanding opportunities of the city. Kearney also celebrated its boosters, or groups of people who actively promoted the improvement and expansion of the town.

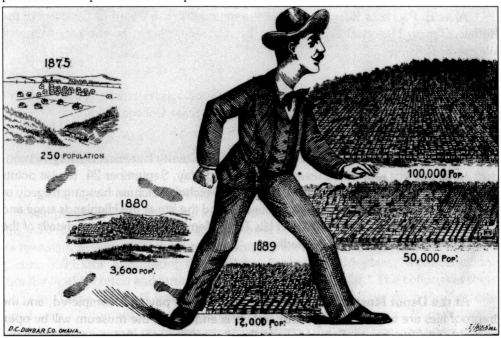

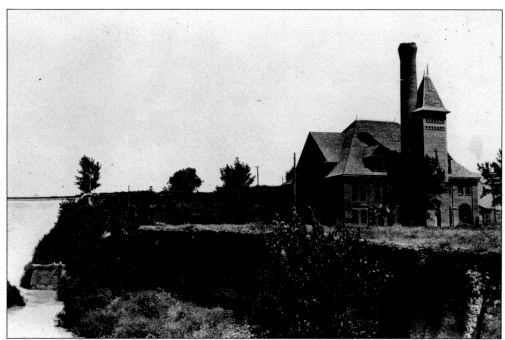

Built in the summer of 1889, the three-story powerhouse was capable of providing 3,000 horsepower to Kearney residents. Located below Kearney Lake, it harnessed the Kearney Canal and helped spur development in West Kearney by demonstrating the usefulness of the canal to possible investors, as well as providing electricity for the first electric trolleys.

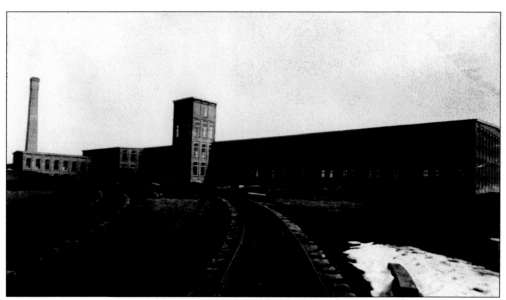

Opened in 1891, the cotton mill was the first of its kind west of the Missouri River. Operating during the economic depression in the 1890s, the mill never made a profit and was closed in 1901. The building was vacant for almost two decades before the ground was bought and an amusement park was built on the property in the early 1920s. Complete with roller coaster and Ferris wheel, the park only operated one season before being destroyed by fire.

Nelson A. Baker became a resident of Kearney in 1879. He was heavily involved in real estate and was a leading promoter of the East Lawn residential neighborhood and Kearney Street Car Company. Baker was elected mayor of Kearney in the spring of 1890 and had a hand in the organization of the chamber of commerce and Kearney Canning Company during the boom.

Ross Gamble arrived in Kearney in 1879 and ranched in the county until 1884, when he sold his ranching interests and bought the Buffalo County Bank in Kearney. The bank was a private institution until Gamble reorganized it into a national bank in 1886, which increased the capital from $60,000 to $100,000. During the business boom, some of the leading businessmen in town were stockholders. He helped organize the Midway Loan and Trust Company, started the Kearney Savings Bank, and gave money to public works and buildings to help the town grow.

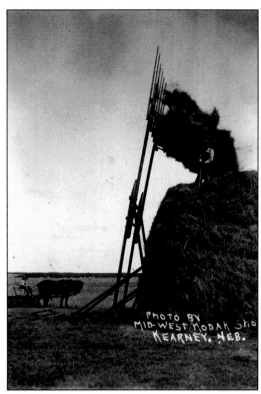

PHOTO BY
MID-WEST KODAK Sho
KEARNEY, NEB.

The main industry for settlers in Kearney was agriculture during its early years. In this photograph from about 1900, farm laborers stack hay in a field, and a train of wagons haul beets to market in Kearney from the Watson Ranch.

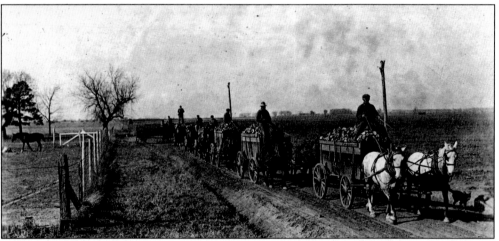

H. D. Watson, part owner of the Watson Ranch, located just west of town, introduced alfalfa to the Midwest. His ranch covered an estimated 7,000 acres of alfalfa, corn, wheat, and orchards, as well as garden crops such as potatoes, cucumbers, squash, celery, and melons. While the Watson Ranch had many farm buildings, its most famous structure was its barn. The barn was 300 feet long, 100 feet wide, and 50 feet tall. The back of the barn was built into a hill so teams of horses could unload hay on the second floor, where 900 tons of hay could be stored. The Wood brothers bought the ranch in 1917 and renamed it 1733 Ranch. In 1935, *Ripley's Believe It or Not!* named it the "World's Biggest Barn." The barn was torn down a few years later after a fire.

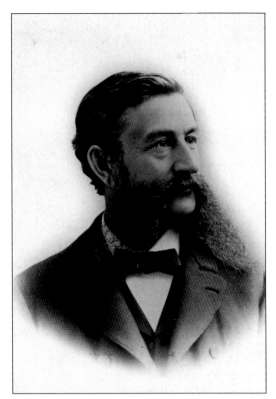

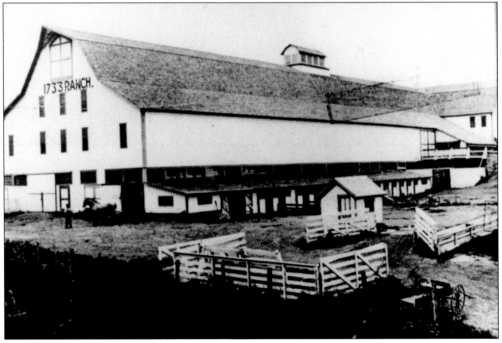

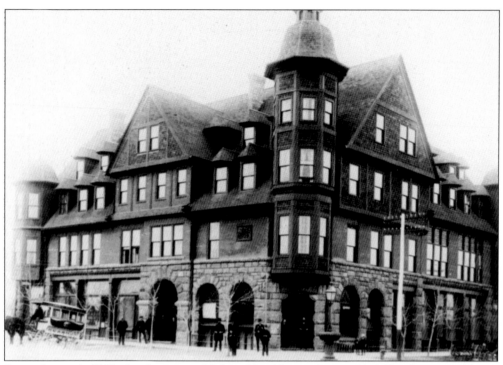

Opened in early 1888, the three-story Midway Hotel boasted a sizeable billiard room and bar, a dining room large enough to seat 100, gaslights, and 80 rooms (most of which had a bathroom and closet). Just before 8:00 a.m. on March 24, 1890, the fire alarms sounded as the roof was being consumed by fire. Although 125 of the guests and employees made it safely out of the building, one man was killed after jumping from a window on one of the top floors.

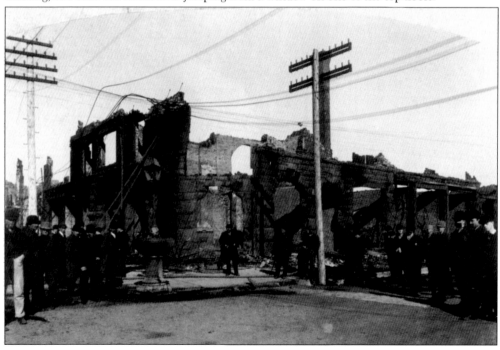

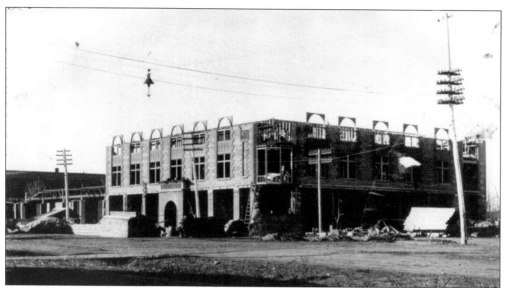

Even though the blaze that claimed the Midway Hotel was controlled with the help of firemen and carts from Grand Island's fire department on the morning of March 24, 1890, the damage had been done. The hotel was destroyed along with everything inside. A decision was made immediately by the chamber of commerce to pledge $6,000 toward building another hotel. The new Midway Hotel was under construction from the fall of 1891 through 1893 and reopened with J. L. Keck, again, as owner.

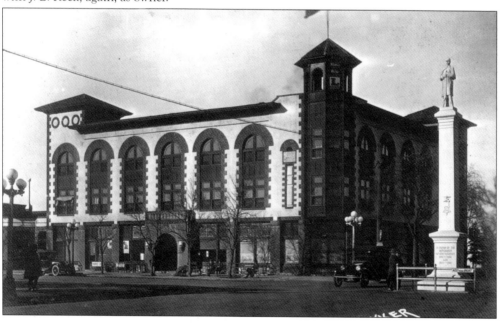

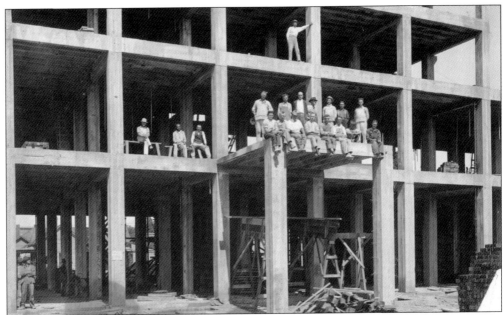

Construction on the Fort Kearney Hotel began in July 1917, at the corner of Twenty-first Street and First Avenue. The hotel excited the community because the proposed seven-story building was to be like those of big cities. Construction halted due to the outbreak of World War I and financial uncertainties. The building stood vacant for 10 years before the Lenore Construction Company of Cedar Rapids, Iowa, finished the hotel and opened it for business in October 1927. A coffee shop and many large rooms were used frequently by town organizations and clubs. Some of its famous guests included Pres. Harry S. Truman, Pres. Herbert Hoover, Pres. Richard Nixon, Cornelius Vanderbilt, Jimmy Dorsey, Igor Piatigorsky, and other sports and entertainment personalities. Despite its rich history, the hotel closed in 1971 and was torn down in 1973 to make way for the First National Bank.

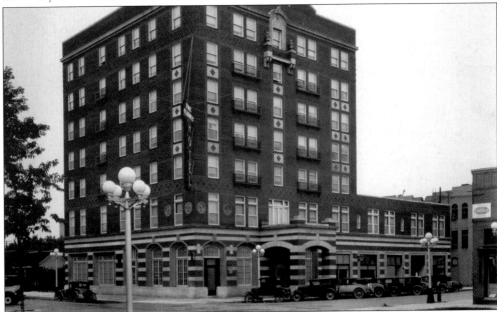

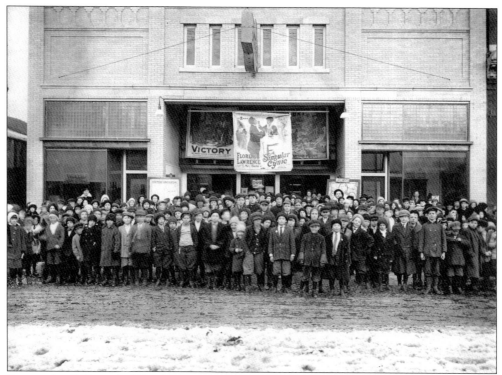

During the 1920s and 1930s, the impressive Opera House was not the only place to see shows. Kearney had a number of theaters, including the Empress, Fort, and World Theatres. The World Theatre still runs its twin cinema today, as well as a drive-in, one of the few remaining drive-in movie theaters in the nation.

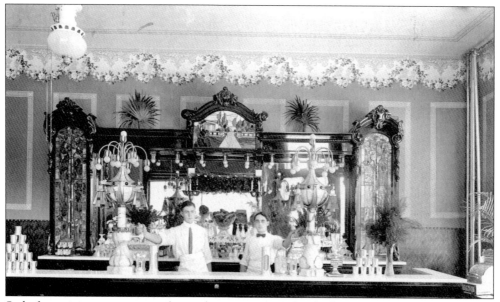

Soda fountains were very popular in downtown stores by the beginning of the 20th century. This soda fountain was located at the corner of Twenty-first Street and Central Avenue.

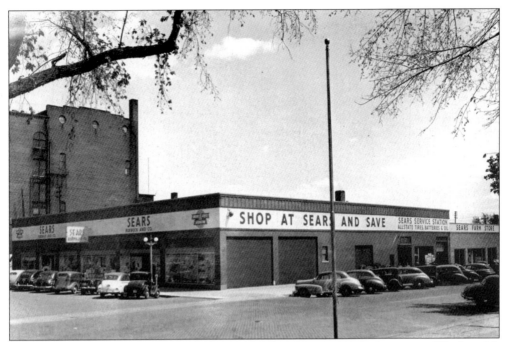

Beginning in the early 20th century, chain stores began appearing in downtown. Woolworth's was popular in the 1920s and 1930s, as was the Sears Service Station after World War II. Although both fared well downtown, neither have stores in Kearney today.

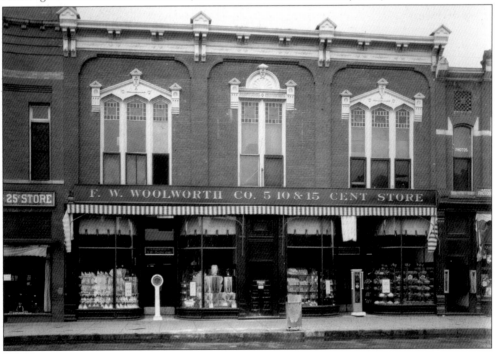

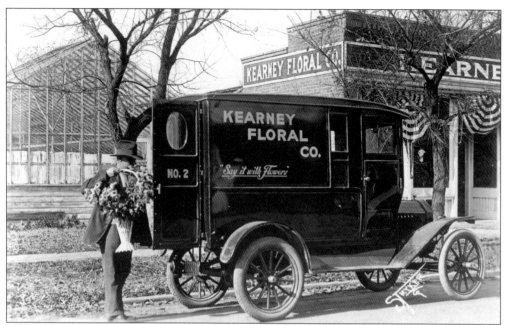

Although many shops have come and gone in Kearney over its history, some stores have survived the ups and downs of the century. Kearney Floral has become a staple of the town through its longevity.

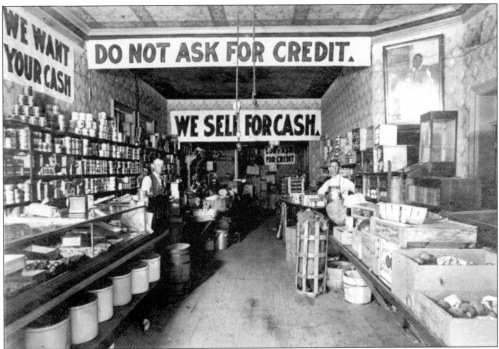

Steele's Grocery, located on Central Avenue in the 1890s, advertises the need for cash payment over credit, most likely due to the declining economy in Kearney during the depression of the early 1890s. Estimates put the loss of businesses and residents at 50 percent during this time. The economy bounced back, surviving the Great Depression of the 1930s. Businesses were prospering by the 1950s, as shown below at Haeberle's Drug Store.

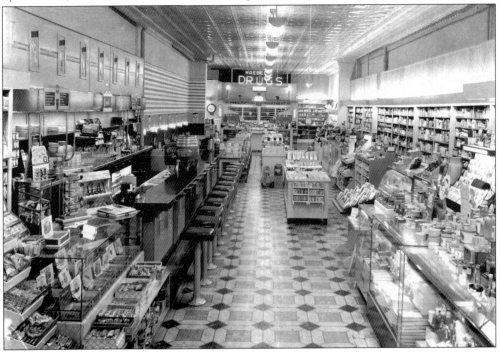

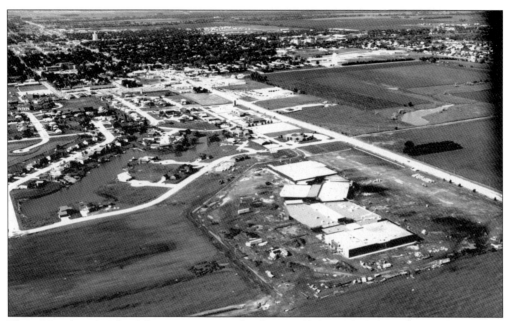

This 1984 photograph of the construction of Hilltop Mall, located at the time on the northern edge of Kearney, shows the expansion of town and the changing appearance of businesses. The main shopping center in town shifted from the downtown area to the retail stores built around the mall. Many of the unique stores on Central Avenue went out of business when a Super Wal-Mart was added north of town in the 1990s.

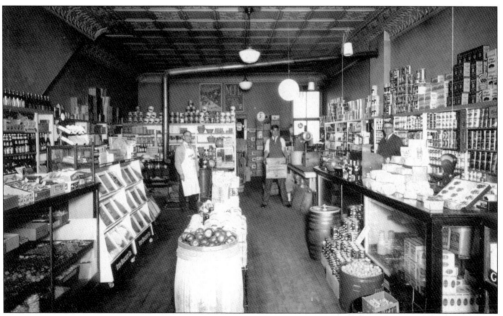

Clerks working at Model Grocery, on Central Avenue, the morning of January 11, 1934, were initially unaware that the Ford V-8 sedan they noticed in front of the Fort Kearney Bank, a few doors north, was the getaway vehicle for four armed robbers. Unaware of the significance of the car at the time, clerks told the police the sedan was parked for over an hour before the 10-minute robbery occurred.

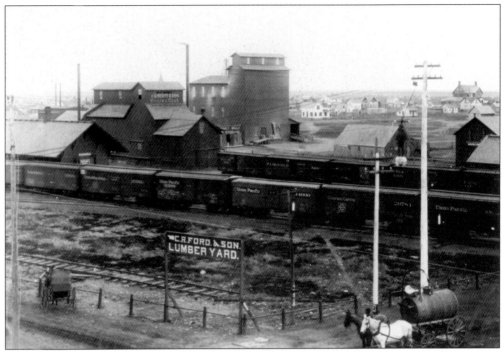

The freight yards saw an explosion in industry during the Kearney boom. During the last years of the 1880s, over 300 carloads of stone were used for new buildings and large Victorian houses.

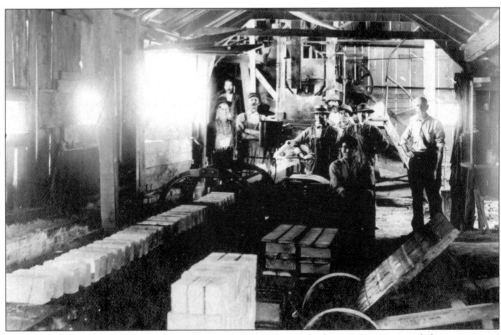

The need for new buildings and a large supply of bricks in the boom years spurred the expansion of the Kearney Brick Company, as well as three new brickyards during 1889. An electric railway was built to ship clay from the banks of the canal to the factories. This photograph shows the workers and interior of a brickyard building.

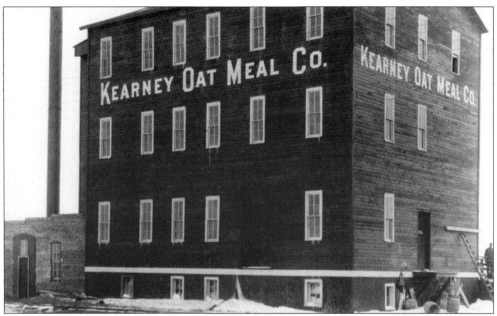

With the rapid growth of industry in Kearney, new businesses sprouted almost overnight. In 1890 alone, three new banks were established. Not only were new industries starting, but old ones were doing better than ever. In 1890, Kearney Milling and Elevator Company employed 16 men and produced around 23,000 barrels of flour. That same year, Kearney Ice Company cut over 9,500 tons of ice.

I have used this truck two years and four months doing general dray and transfer work, and have never spent a dollar for repairs or been laid up a minute.
Pat. Hayward.

The Kearney boom ended as drought and economic depression entered Nebraska in the early 1890s. The grandiose visions of an ever-expanding Kearney waned as leading investors went bankrupt. The town bounced back slowly over the first half of the 20th century, until the Great Depression gave Kearney more economic hardships. The town has proven resilient, and today's economy is as strong as ever.

In the early years of the 21st century, Kearney's downtown has witnessed a revival. Restaurants, coffee shops, breweries, and MONA have added a local flavor to the downtown. Baristas is an award-winning café and bakery that provides outdoor seating and entertainment. Established in 1999, Thunderhead Brewing offers more than a dozen handcrafted beers that are brewed in-house. In 2004, the brewery won a gold medal at the World Beer Festival for its acclaimed Black Sheep Espresso Stout.

Three

TRAILS, RAILS, AND TIRES

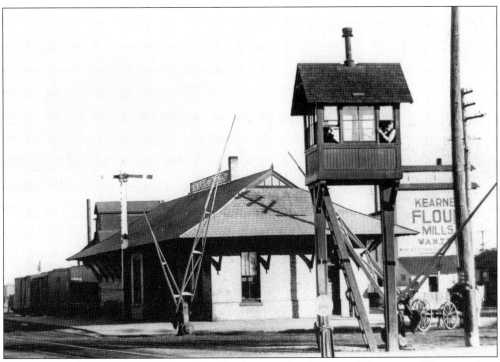

Changing methods of transportation have both created and changed the town of Kearney since its establishment. Beginning as a stop along the railroad, Kearney's growth relied heavily on its location along the transcontinental railroad, the Lincoln Highway, and Interstate 80. The history of early Kearney parallels the history of the railroad in the area. The Burlington Railroad finished tracks from southeast Nebraska to the town of Kearney Junction in September 1872 and most likely used a boxcar as the first depot. The railroad sold many of its town lots, including half of them to the Union Pacific Railroad.

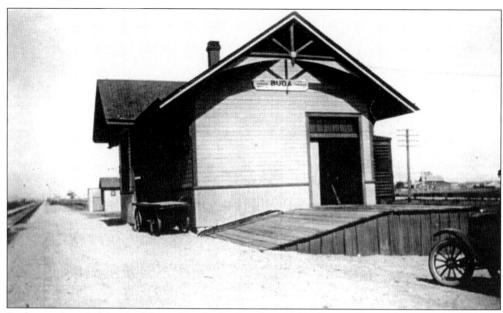

Buda was founded by the Union Pacific Railroad in 1866. Originally named Kearney Station, it was located directly north of Fort Kearny across the Platte River. When the 600 residents discovered that their town was located on the fort's military reservation, most moved elsewhere. Soon only the depot and section house remained. The depot was eventually renamed Buda due to confusion with the new town of Kearney Junction, located several miles west.

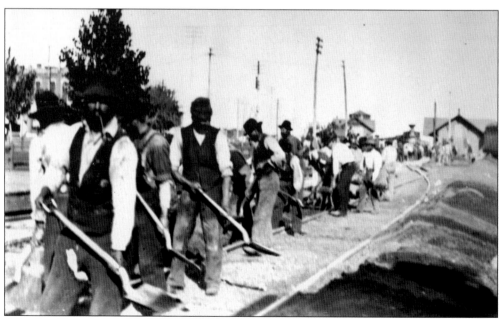

After Fort Kearny closed in 1877, land was available for settlement at Buda, but the then-flourishing towns of Kearney Junction (five miles to the west) and Gibbon (seven miles east) were more appealing to settlers. Above, laborers work on additional tracks at the Kearney depot. Presently the town of Kearney has almost grown right next to the few buildings and residences that still make up the community of Buda.

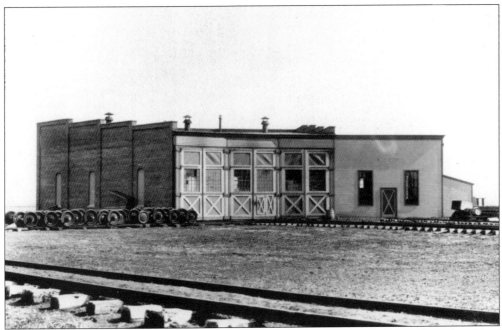

Because the Burlington Railroad had a depot in Kearney first and the Union Pacific Railroad had a depot in Buda and did not make stops in Kearney in the early 1870s, the railroad companies decided to share a common station. Construction of the new Burlington depot, just east of Wyoming (later Central) Avenue, began as early as the fall of 1872. The roundhouse (above) and water tank were built farther east.

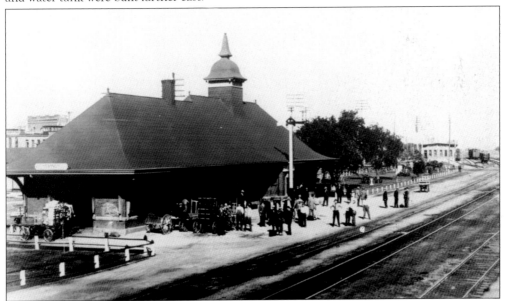

The Union Pacific Railroad closed the Buda office and shared the Kearney depot with the Burlington Railroad. The agent from Buda then became the Union Pacific agent in the north side of the Burlington depot, while the Burlington agent worked in the south section of the building. By 1890, the Union Pacific Railroad built a sizeable depot of its own, located where First Avenue meets the tracks. This photograph shows the busy depot in 1911.

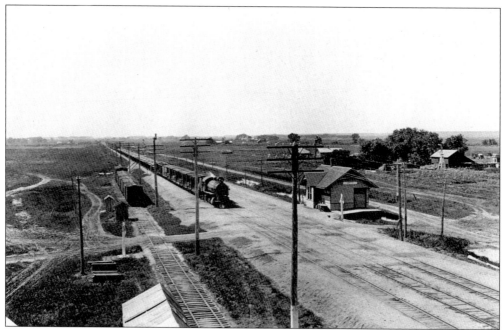

Odessa is located about 10 miles west of Kearney. The depot was established when the transcontinental railroad passed through the area, and from 1866 to 1871, it was known as Stevenson's Siding. The town was renamed Odessa in 1876. As of the 2000 census, fewer than 400 people lived there, and in 2006, this depot is located at a private residence.

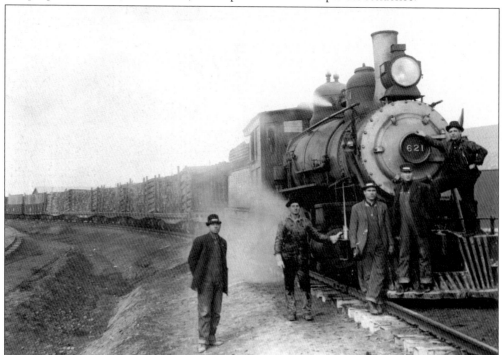

In later years, people in Odessa could board the eastbound train in the morning, come to Kearney, do their shopping, catch a westbound train in the late afternoon, and return home to Odessa.

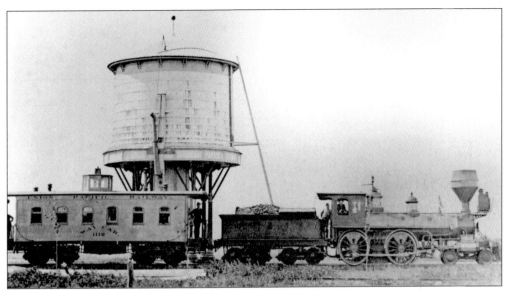

Much like this image of a small locomotive, engine No. 10, taken in Buffalo County in 1884, steam-powered engines needed to stop about every 10 to 20 miles to refill their water supply. Established solely around the railroad, many towns along the tracks disappeared as engines were improved and there was no need to stop so frequently.

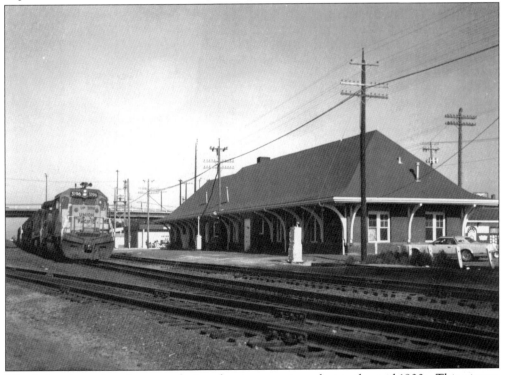

Diesel-electric engines began replacing the steam engines during the mid-1900s. This picture of a diesel-electric engine next to the Kearney depot in the 1970s is a unique image of old and new and became more sentimental a few years later when the depot was removed. The railroad through Kearney is currently used almost solely for shipping freight and coal.

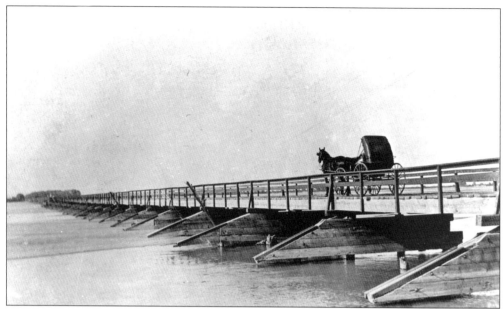

In the 1870s, a bond of $42,000 was proposed to the town of Kearney to fund a bridge south of town. The bridge was suggested as a way to allow people living on the south side of the Platte River easy access to Kearney for economic reasons. The Burlington Railroad was not in favor of the bridge and tried to command certain local employees to oppose the bonds and rally their friends against them, too. The bonds passed, and lumber for the bridge was shipped to Kearney on the Burlington Railroad lines and unloaded, but because the Burlington Railroad had taken such a strong stance against the bridge, an injunction against the use of this lumber was served, and for over a year, the lumber was left in the yard until the matter was resolved. The wooden bridge was replaced with a concrete one a few decades later.

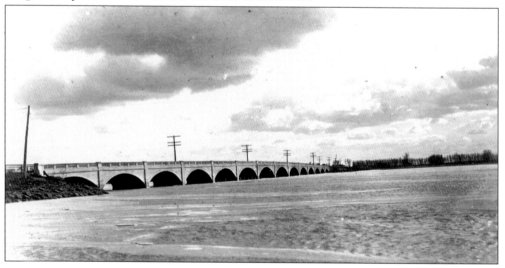

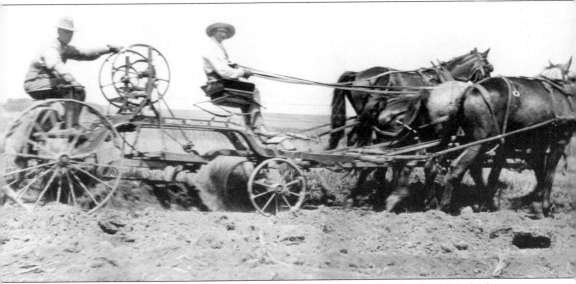

The Lincoln Highway Association mapped out a proposed route for the first U.S. highway to span the nation from coast to coast, which was completed in 1913. Starting in New York, the highway would go through New Jersey, Pennsylvania, Ohio, Indiana, Illinois, Iowa, Nebraska, Colorado, Wyoming, Utah, and Nevada, and end in California. This photograph shows men doing roadwork near Odessa in 1913.

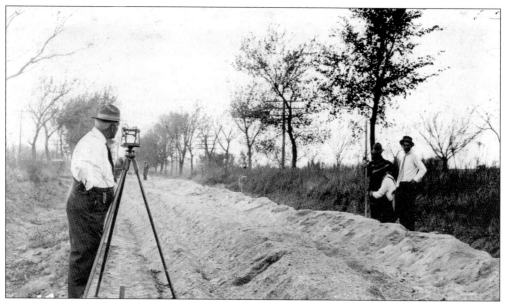

The Lincoln Highway Association estimated that $10 million would need to be raised to pave the road to make it usable for motorcars in all kinds of weather. Instead of raising the entire amount of money before starting, a plan was adopted to only pave sample miles (named "seedling miles") at various intervals for the public to see how much better pavement was to drive on than dirt and to encourage locals to sponsor their own seedling miles. After Grand Island applied for money to create a seedling mile in late 1914, Kearney became instantly interested in funding its own. Pictured here, a surveyor works on Watson Boulevard, a favorite area for travelers to stop and picnic and the desired location for Kearney's first seedling mile.

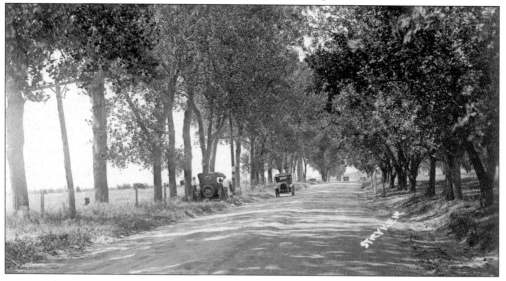

The Kearney Commercial Club raised donations of money and materials to allow for a wider road (15 feet wide instead of the 10-foot width started in Illinois) to be paved on West Twenty-fourth Street ending at the industrial school, a stretch of road known as Watson Boulevard. Paving of the road took place from October 19 through November 6, 1915.

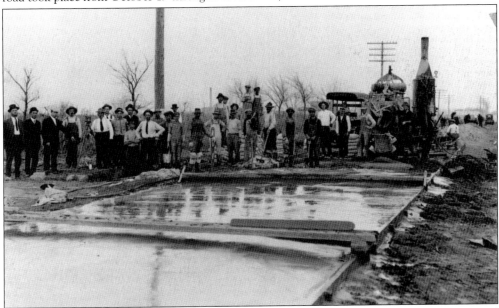

In 1922, the Lincoln Highway Association realigned the route of the Lincoln Highway, and changes were undertaken in Nebraska. Because the roads originally followed section lines, the highway went back and forth across the Union Pacific Railroad tracks (a total of 29 grade crossings), which not only added mileage but also caused numerous accidents. After an agreement was made with the railroad, a straighter route was established across the state.

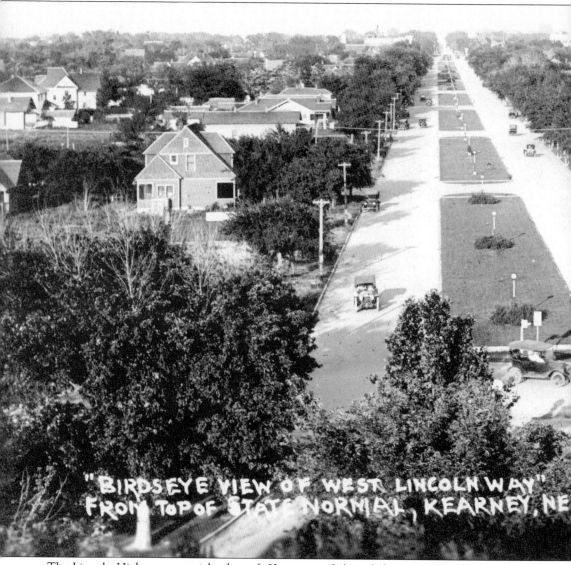

"BIRDSEYE VIEW OF WEST LINCOLN WAY"
FROM TOP OF STATE NORMAL, KEARNEY, NE

The Lincoln Highway went right through Kearney and skirted the state normal school on the west side of town. This photograph was taken from the top of the administration building on the

52

campus, looking east at the highway in the 1920s.

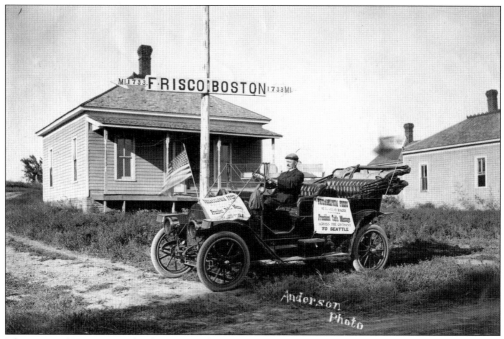

The town of Kearney took advantage of its exact location between San Francisco and Boston on the Lincoln Highway. Advertising heavily that it was 1,733 miles from Boston and 1,733 miles from San Francisco, Kearney was celebrated as the "Midway City."

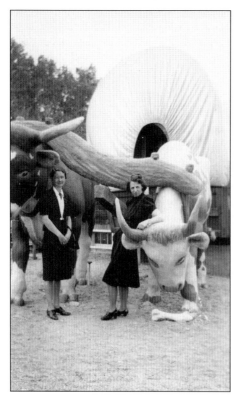

The Watson Ranch, located on the first seedling mile outside of Kearney, changed its name to 1733 Ranch, and many of the businesses in the area also sported the title. The 1733 Motel, located just west of town, built the large oxen and covered wagon by its building to attract the attention of travelers.

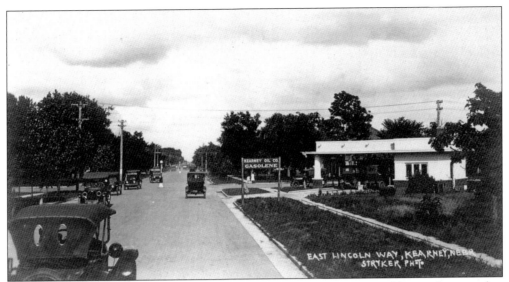

Homes and businesses along the Lincoln Highway in town were given addresses designated as "Lincolnway" in directories. In 1924, the Lincoln Highway became federal Highway 30, and the term "Lincolnway" faded away.

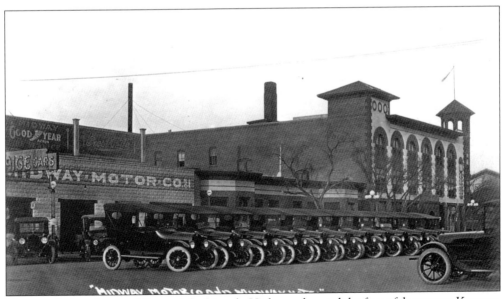

The popularity of automobiles and the Lincoln Highway changed the face of downtown Kearney. Midway Motor Company, show in this photograph, proudly advertises its cars in the street. The business was located next to the city's local landmark, the Midway Hotel, on Twenty-fifth Street (the Lincoln Highway), between Central Avenue and First Street.

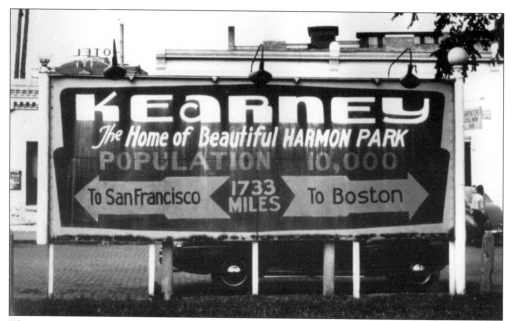

This photograph of a sign, taken in the early 1940s, shows not only that Kearney was proud of its location between coasts but also its growing population. From the time Kearney built its seedling mile to the 1940 census, the population of the city rose by 3,000 persons. When Interstate 80 was completed roughly 25 years later, Kearney had almost reached a population of 20,000 people.

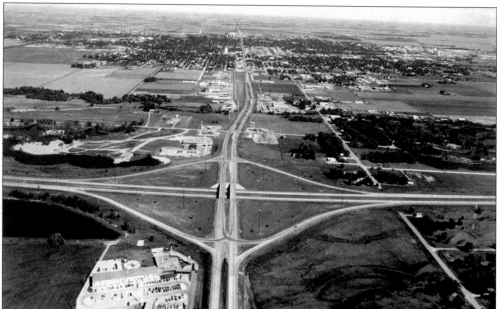

Interstate 80 is also a transcontinental road. Unlike the Lincoln Highway that bisected each of the local towns it went through, the interstate was constructed outside of the towns in Buffalo County, but parallel to Highway 30. This photograph of exit No. 272, Kearney's exit, shows the interstate about a mile south of town. Currently, in the 21st century, the town has grown to the exit through the construction of fast-food restaurants and chain hotels.

Four

FOR THE PEOPLE, BY THE PEOPLE

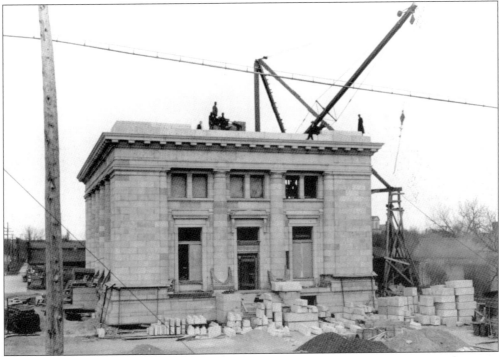

From 1872 until 1910, when the building above was constructed at the corner of Central Avenue and Twenty-fourth Street, the Kearney post office never had a permanent home. The first post office for Buffalo County was established at Fort Kearny in 1849. The pony express, during its brief lifespan, also provided mail service to the area. Shortly after Kearney was platted in 1872, a post office was established with Asbury Collins as postmaster, but it regularly moved from location to location. During the 1890s, the post office was housed at several downtown locations, including 2111 Central Avenue and 15 West Twenty-second Street. Finally, with the completion of the ornate building pictured in this photograph, the Kearney post office had a home. Today this building is home to MONA.

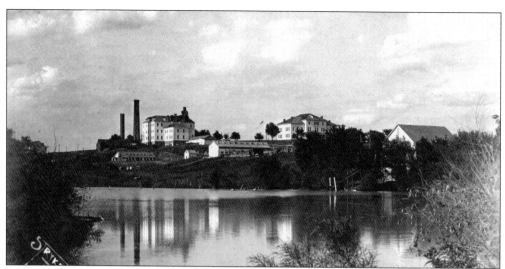

In 1879, the state legislature appropriated $10,000 for the construction of a reform school at Kearney. The City of Kearney donated a 300-acre tract of land three miles west of town, and on July 12, 1881, the Nebraska State Reformatory opened. The school admitted both boys and girls until 1892, when a separate institution for girls was established at Geneva. The view above of the institution was taken from the Lincoln Highway (modern-day Highway 30) by John Stryker around 1920. The main building and living quarters are pictured below. Much of the school's grounds, including this beautiful lake, is now occupied by the municipal golf course.

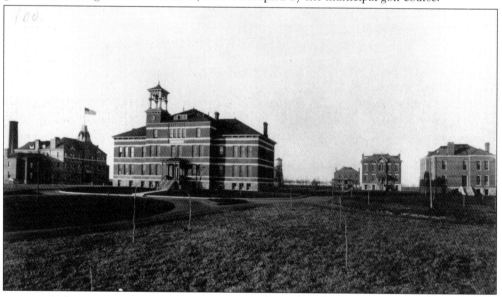

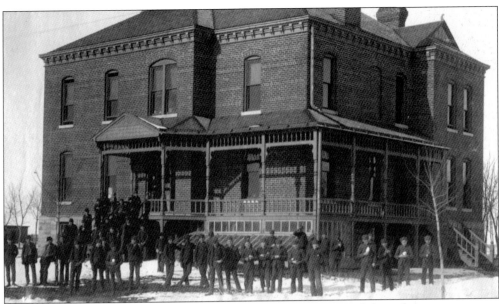

Located several miles west of downtown Kearney, the purpose of the reformatory was not punishment or confinement but rather reform and education. Thus, the reformatory's goal was to save Nebraska's young male delinquents before they fell into a life of crime. This was to be accomplished by teaching the young men to respect themselves and society. Rather than living behind bars, those sent to the state reformatory lived in cottages in family-oriented conditions with boys of a similar age and temperament. They attended school for half the day and then worked in the fields or shops. With a proper education and equipped with a viable trade or occupation, a former juvenile delinquent could leave the reformatory and become a useful member of society. To erase any connection to penal institutions, the legislature changed the name in 1887 to the State Industrial School for Boys. Today the state institution is known as the Youth Rehabilitation and Treatment Center.

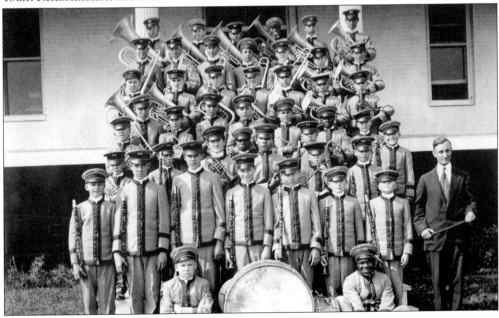

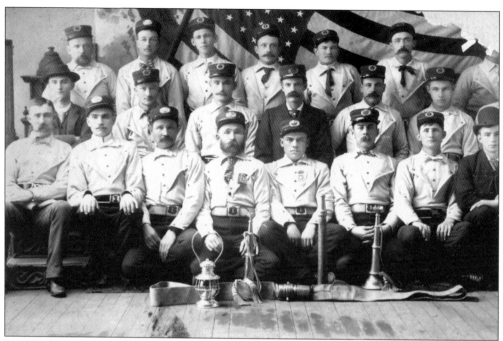

In 1883, fighting fires moved beyond the ineffective bucket brigade system when the city installed water hydrants. Soon after, on September 30, 1883, the Kearney Volunteer Fire Department was officially organized. Volunteers were divided into companies of 25 and served on a specific piece of fire equipment. During the 1880s and 1890s, firemen could serve either on the Kearney Protection Hook and Ladder Company or the Kearney Wide-Awake Hose Company. Members of the Kearney Wide-Awake Hose Company, coached by a New Yorker named G. Kramer, won many state and national championships in hose coupling and cart pulling. Pictured above is one of Kramer's championship teams. Pictured below is one of the department's original fire trucks.

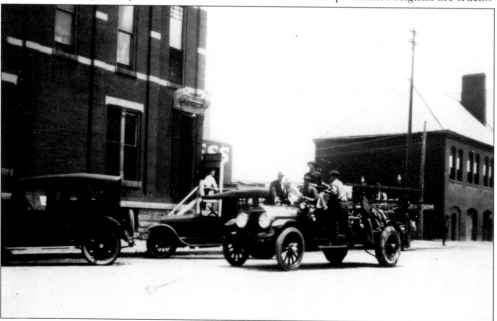

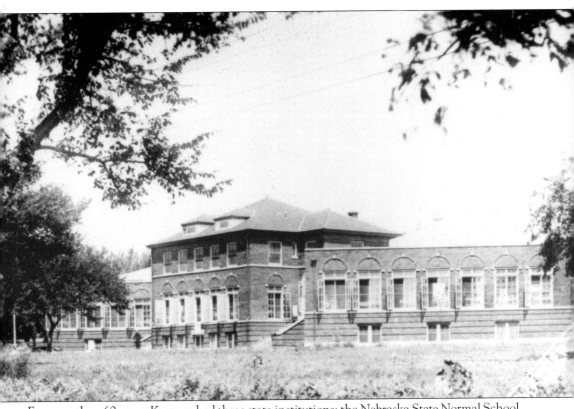

For more than 60 years, Kearney had three state institutions: the Nebraska State Normal School, the State Industrial School for Boys, and the Nebraska State Hospital for the Tubercular. From 1912 to 1972, the hospital provided medical help to those suffering from tuberculosis. Now known as West Campus, it is part of the University of Nebraska at Kearney.

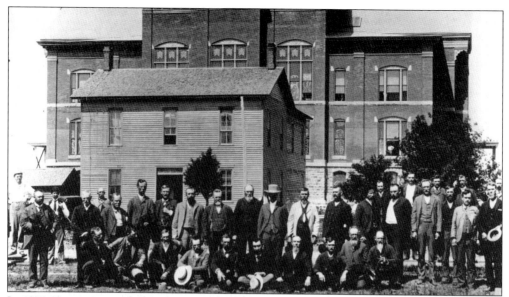

In 1874, Kearney wrestled the county seat away from Gibbon in a hotly contested county seat election. Strangely, the county courthouse is not near the downtown business section like in many Nebraska towns. This is because the Union Pacific Railroad donated land for the construction of a courthouse on the south side of the tracks, farther down Central Avenue. This photograph shows the old wooden courthouse that was funded by the railroad and the new courthouse that was completed in 1890. This elegant Buffalo County Courthouse served the county until 1973 when the new courthouse was completed.

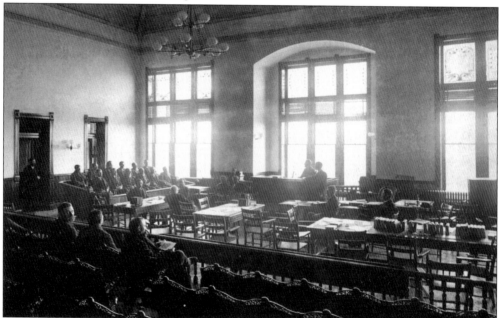

This rare view of the inside of the Buffalo County Courthouse shows a trial in progress. Judge Francis Hamer, who later became a Nebraska Supreme Court justice, presided over this courtroom during the early 1890s. Norris Brown, who later became a United States senator, argued hundreds of cases in the same courtroom.

To the locals, Judge William Gaslin was known as a "terror to evildoers." Gaslin served as a district court judge for over 20 years and presided over several high-profile murder cases. He made a habit out of handing out the maximum sentence to convicted criminals. His most famous trial was the murder trial of Print Olive, a cattle rancher who killed two farmers during the 1870s.

Francis (Frank) Hamer was one of Kearney's founding fathers. Arriving in 1872 with his wife Rebecca, he opened Kearney's first law office. He served three terms as a district court judge for western Nebraska, and in 1911, he was elected to the Nebraska Supreme Court. Hamer worked diligently to promote and build Kearney into a prosperous town. Among other things, he helped locate the county seat at Kearney, financially supported several churches, backed the movement to bridge the Platte River, and supported Kearney as the location for the State Industrial School for Boys.

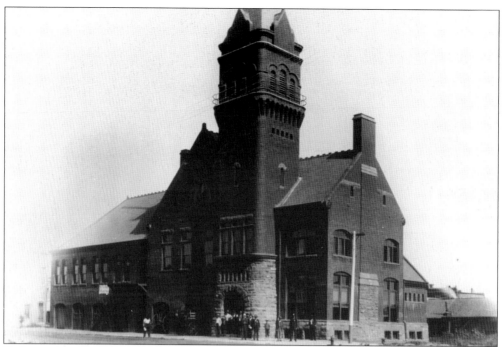

Early city business was conducted at a building located at the corner of Twenty-first Street and Avenue B. In 1889, a new city hall was built at the corner of Twenty-second Street and Avenue A for a cost of $25,000. This building served as Kearney's city hall from 1889 to 1939. Not only did the building house city offices, but it also was the home to the city's fire and police departments. During its heyday, it was considered to be one of Kearney's premier buildings. The new city building, pictured below, sits on the same location.

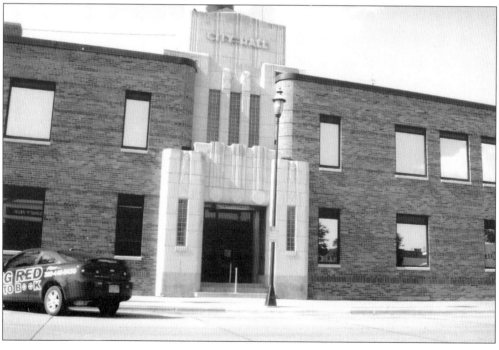

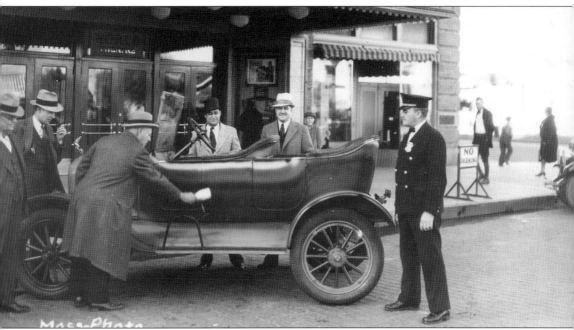

In 1873, Kearney's police force got its start with a single town marshal. Over the course of the 19th century, a night watch and several full-time police officers were added to the force. Silas P. Funk, an early Kearney marshal and Buffalo County sheriff, gained notoriety in the 1890s as a Union Pacific special detective who tracked train robbers such as Butch Cassidy and the Sundance Kid. By the 1920s, the police force utilized the automobile. Christening the city's first police car are several city councilmen and police chief Lloyd Frank (far right). In 2006, the Kearney Police Department employs 40 officers.

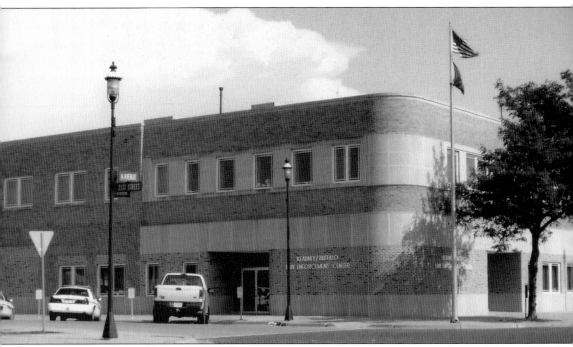

In 1993, the Buffalo County Sheriff's Office and the Kearney City Police moved into this building located at the corner of Twenty-first Street and Avenue A. The two agencies not only share the same building but share resources. The sheriff's office takes care of dispatch duties and 911 calls, while the police department oversees the records and data-processing functions for both agencies. The sharing of duties and resources saves taxpayer dollars. This system is considered a model of intergovernmental cooperation throughout the Great Plains.

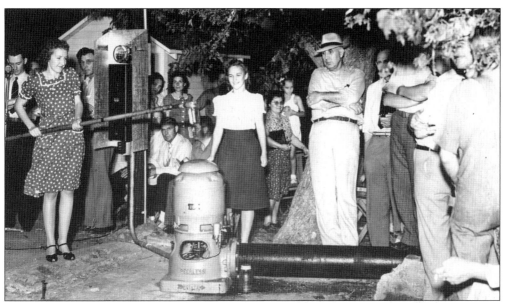

At the height of the Great Depression in 1933, the national unemployment rate stood at 25 percent. Under Pres. Franklin D. Roosevelt's New Deal programs, millions of unemployed Americans were put to work on public works projects through agencies such as the Public Works Administration and the Works Progress Administration. In Kearney, the razing of the old city hall (pictured below) and construction of the new building was partially funded by the Works Progress Administration. Other Works Progress Administration and Public Works Administration projects included Men's Hall dormitory and the football stadium and track at the state college, the municipal airport, Kenwood Elementary School, and the Harmon Park pool, entertainment stage, and rock garden. New Deal programs also introduced farm programs and irrigation. In the photograph above, the 100th well tapped by the Rural Electrification Administration is dedicated just outside of Kearney.

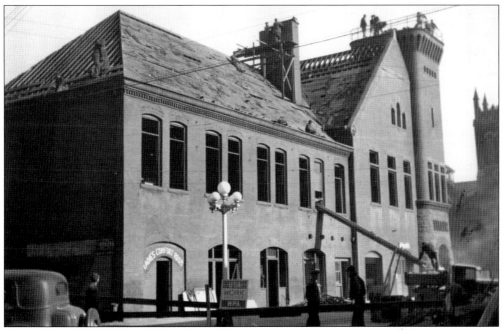

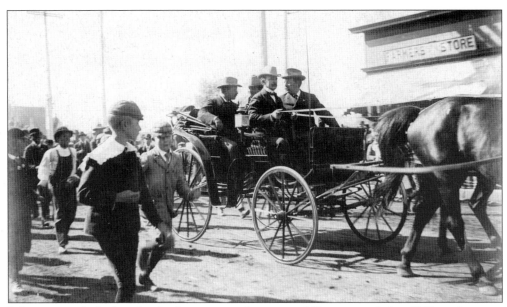

Politicians at the highest levels of government have visited Kearney, including William Jennings Bryan, Pres. William Howard Taft, Pres. Theodore Roosevelt, Robert "Fighting Bob" LaFollette, Pres. Harry S. Truman, Pres. John F. Kennedy, Pres. Richard M. Nixon, and Pres. Bill Clinton. In the photograph above, excited youngsters chase a carriage escorting Roosevelt up Central Avenue. Roosevelt is seated on the left in the backseat.

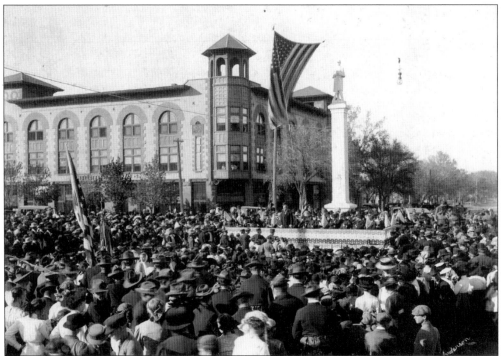

In this photograph, U.S. senator Norris Brown of Kearney dedicates the Soldiers Monument at the intersection of Central Avenue and Twenty-fifth Street. A reported 15,000 people attended the dedication ceremony on October 25, 1910.

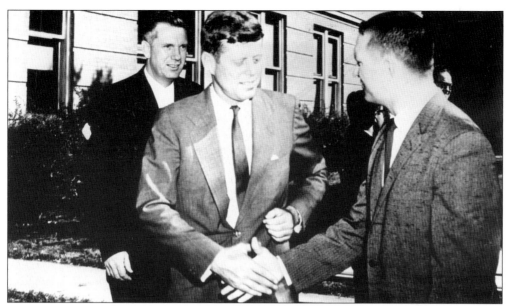

During the 1960 presidential
campaign, both Richard M. Nixon
and John F. Kennedy visited
Kearney. During his visit, Senator
Kennedy addressed an overflowing
crowd in the auditorium at the
Nebraska State Teachers College.
Here he is seen shaking hands with
a student. Nixon visited Kearney
during his failed 1960 presidential
campaign and his successful 1968
campaign. Here he is pictured
in 1960 addressing a throng
of enamored supporters at the
municipal airport.

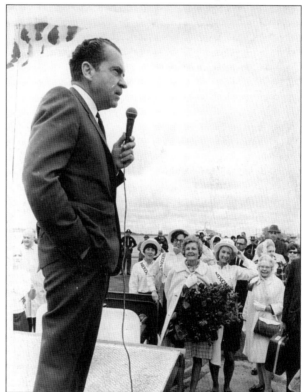

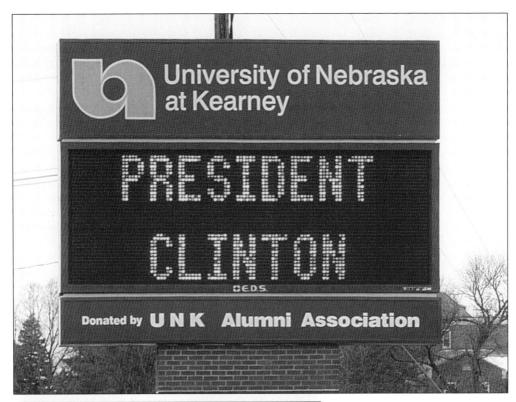

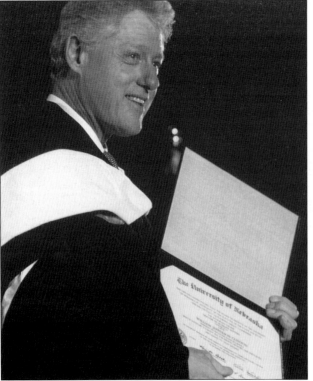

On December 8, 2000, Pres. Bill Clinton fulfilled his promise to visit all 50 states during his presidency with a visit to Kearney. After a brief motorcade through the streets of Kearney, President Clinton arrived at the University of Nebraska at Kearney where he addressed an overflowing crowd in Cushing Coliseum. After being presented with an honorary degree from the University of Nebraska, he visited the Archway Monument.

Five

CITY OF EDUCATION

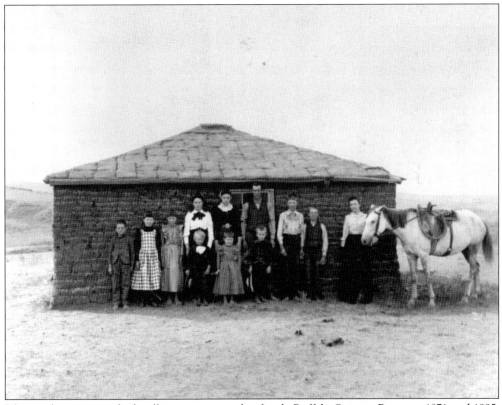

The rural, one-roomed schoolhouse was a staple of early Buffalo County. Between 1871 and 1895, residents of the county built 120 schools. Teachers were generally young, single women. In 1919, for example, the average age of a schoolteacher in Nebraska was only 21. Rural teachers usually boarded with local families and were paid paltry salaries. School terms coincided with the agriculture cycle. Terms generally began after the fall harvest and ended before spring planting.

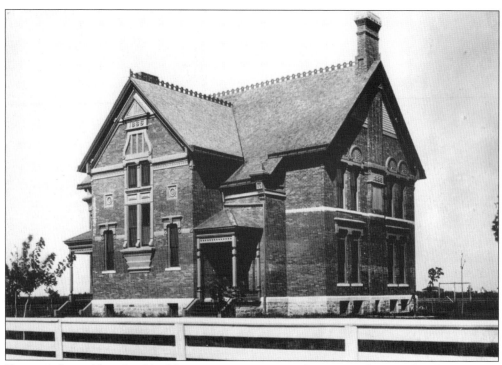

Kearney's first public school building was a two-story wood structure that stood at the corner of Twenty-fourth Street and Avenue A. With an increasing population during the 1880s, Kearney was divided into four wards, each with its own brick schoolhouse. Bryant (pictured above) and Emerson Schools were built in 1885 and looked identical. Pictured below is Kenwood Elementary, erected in 1888. These buildings were all razed and replaced by the early 1950s.

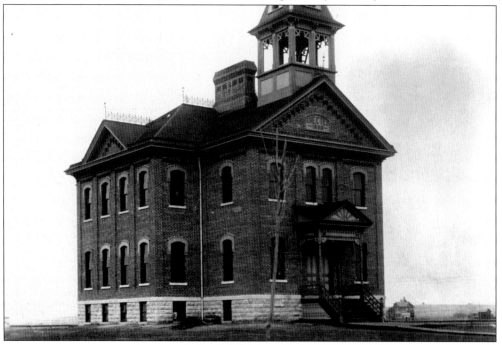

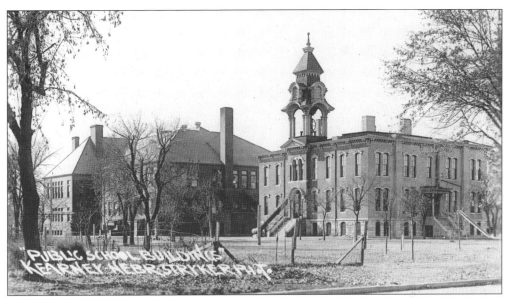

Pictured below is Whittier School, the first brick schoolhouse in Kearney. Erected in 1879, Whittier served as both a grade school and high school until Longfellow High School was built in 1890. Thereafter, Whittier served as an elementary school, junior high, and later as a manual arts building for the high school. In 1905, students attending the first session of the normal school had classes in Whittier while the buildings at the college were being completed. Longfellow High School, pictured above with "Old Whittier," served as the high school until the present-day high school was opened in the 1960s. Longfellow High School was razed in 1969.

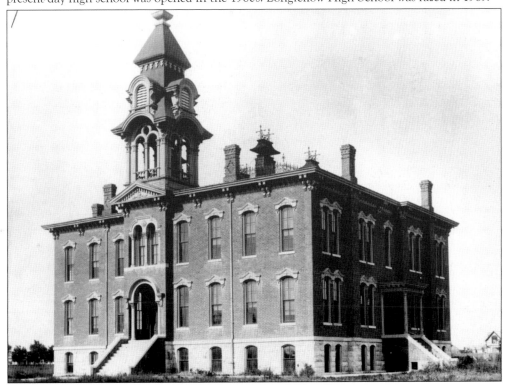

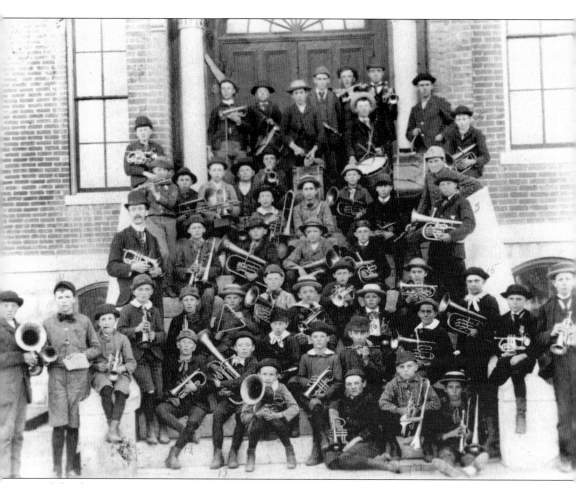

School activities such as sports, drama, and music have always played an important role in students' education. Pictured here is the grade school band on the steps of the Old Whittier School building.

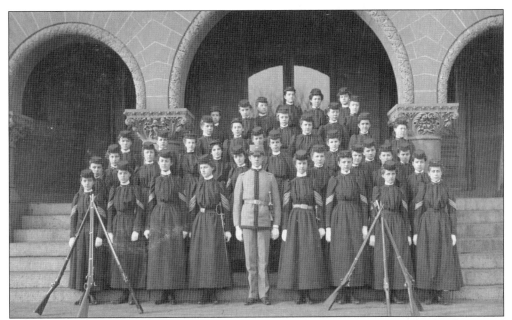

In 1900, Professor Morey, the longtime school superintendent of Kearney public schools, created a boys and girls cadet company. After securing guns from the state, Morey drilled the young cadets three times a week on the school grounds around Longfellow High School. During poor weather, the cadets drilled at the National Guard armory. The girls' company is pictured here with its male officer on the steps in front of Longfellow High School.

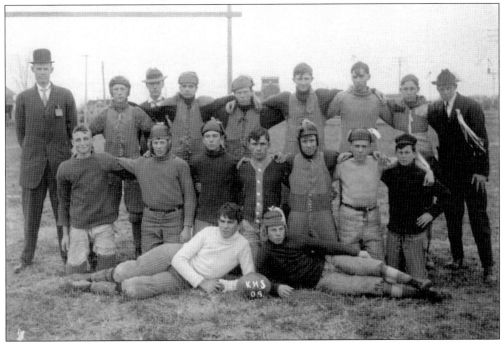

During the early 1900s, football began to challenge baseball as the most popular sport in Nebraska high schools. In 1909, the Kearney High School football squad played teams such as Grand Island, Hastings, North Platte, and the normal school at Kearney.

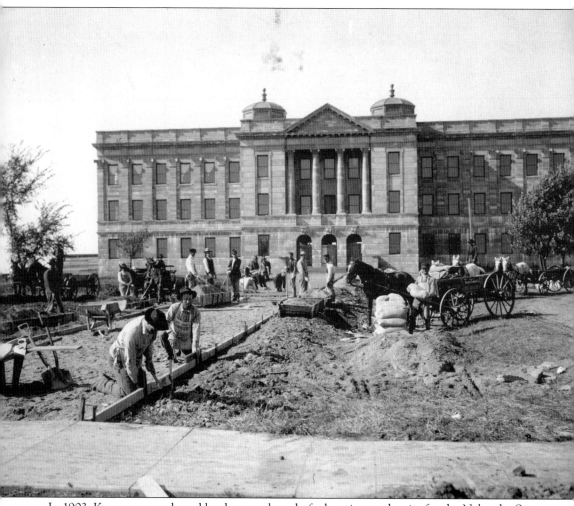

In 1903, Kearney was selected by the state board of education as the site for the Nebraska State Normal School. The city's winning bid was valued at $91,000 and included a 23-acre tract of land and a dormitory for students. The battle for the normal school was a long and fierce fight that pitted 15 communities against one another. Aurora was particularly bitter over losing out to Kearney. The *Aurora Sun* reported that "from a moral stand point the board selected the worst in the entire list. [Kearney] is noted for its saloons, grafters, and houses of prostitution." The state allocated $50,000 for the building, and the cornerstone was laid on October 18, 1904. (Courtesy of the Calvin T. Ryan Library, University of Nebraska at Kearney.)

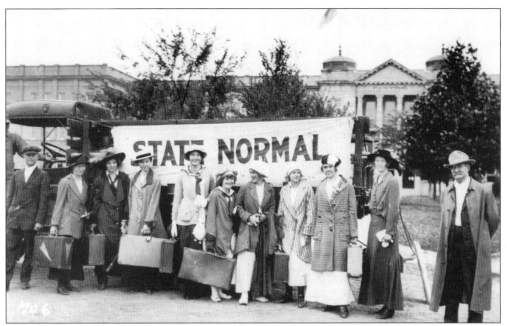

One of the selling points that Kearney used to acquire the normal school was that both the Union Pacific and Burlington Railroads serviced it. Students arriving at either the Union Pacific or Burlington depots (both were located near the present-day intersection of Central Avenue and Railroad Street) were escorted to the college by this truck. (Courtesy of the Calvin T. Ryan Library, University of Nebraska at Kearney.)

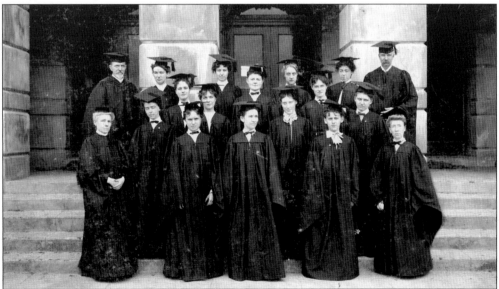

The first session of school began with 120 students (113 women and 7 men) during the summer of 1905. The first classes were held at Longfellow High School and Whittier. Classes were moved on campus during the fall session and enrollment jumped to over 400 students. These students represent the first graduating class in 1906. Without a campus auditorium, commencement was held downtown at the Kearney Opera House. (Courtesy of the Calvin T. Ryan Library, University of Nebraska at Kearney.)

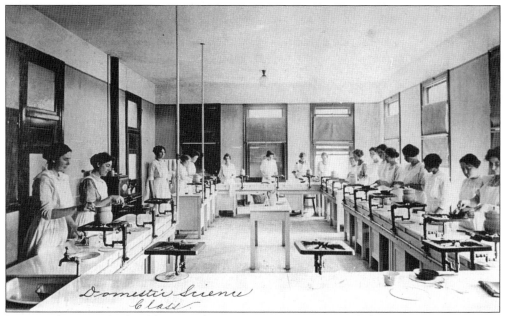

In 1909, the normal school began a domestic science program to help prepare young women for marriage and family. Headed by Marion Williams Wellers, the program offered courses in composition and production of meals, dressmaking, home construction, and even plumbing. (Courtesy of the Calvin T. Ryan Library, University of Nebraska at Kearney.)

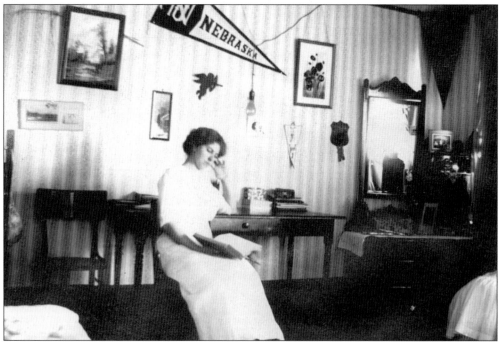

In the early years of the normal school, female students were required to live on campus at Green Terrace. The building contained 42 dorm rooms, equipped with iron beds, closets, desks, dressers with plate glass mirrors, and washstands. (Courtesy of the Calvin T. Ryan Library, University of Nebraska at Kearney.)

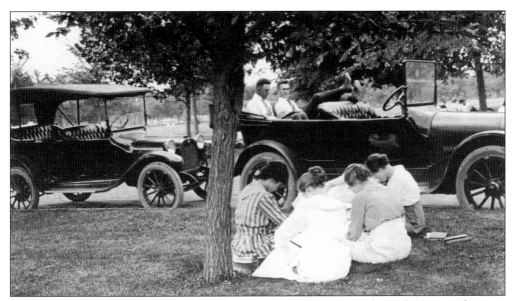

Students took a full load of courses at the normal school. During the early years, a first-year student completed 37 credits during the year. To graduate, a student was required to complete 160 required hours and 40 hours of electives. Pictured here are students studying on the lawn in front of the administration building. (Courtesy of the Calvin T. Ryan Library, University of Nebraska at Kearney.)

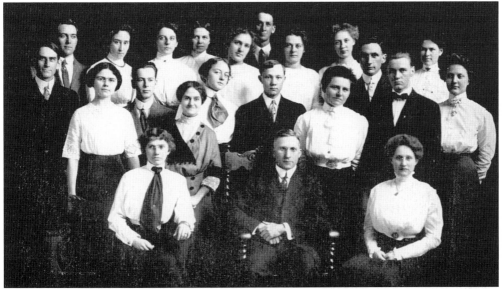

The History Club was founded in May 1911 by Prof. C. N. Anderson (seated in the chair). Under Anderson's direction, students worked to preserve the "stories and deeds of Nebraska's pioneers." Students gathered several times per semester to discuss things such as Fort Kearny, ranching and ranch life, and the Oregon and Mormon Trails. During the second decade of the 20th century, the club began collecting artifacts related to Fort Kearny and recorded the oral histories of many early Buffalo County pioneers. Today the History Club at the University of Nebraska at Kearney has been joined with Phi Alpha Theta, the national history honors society. (Courtesy of the Calvin T. Ryan Library, University of Nebraska at Kearney.)

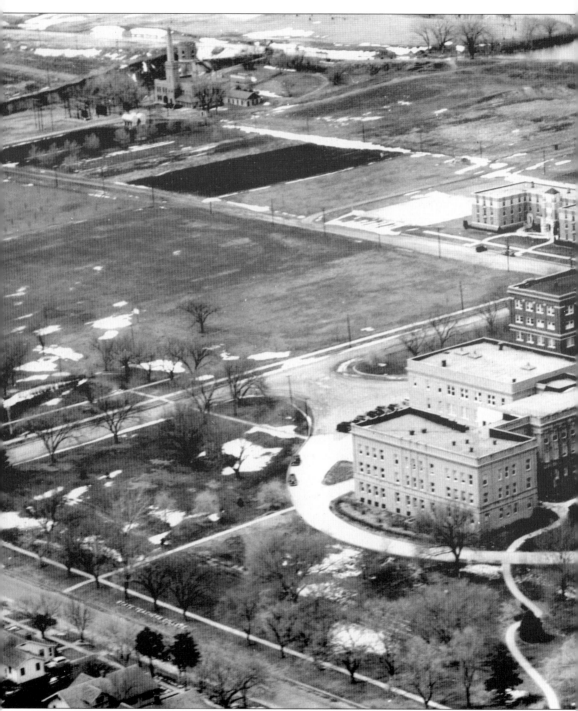

This aerial view of the campus, taken around 1940, shows many of the original buildings. The old administration building went through three expansions. The original building (officially known as the Mickey Building) was completed in 1905, but with an unexpected growth in student population, expansion came quickly. The north wing (Shellenberger Building) was added in 1909–1910 and the south wing (Aldrich Wing) in 1911–1912. An auditorium was added

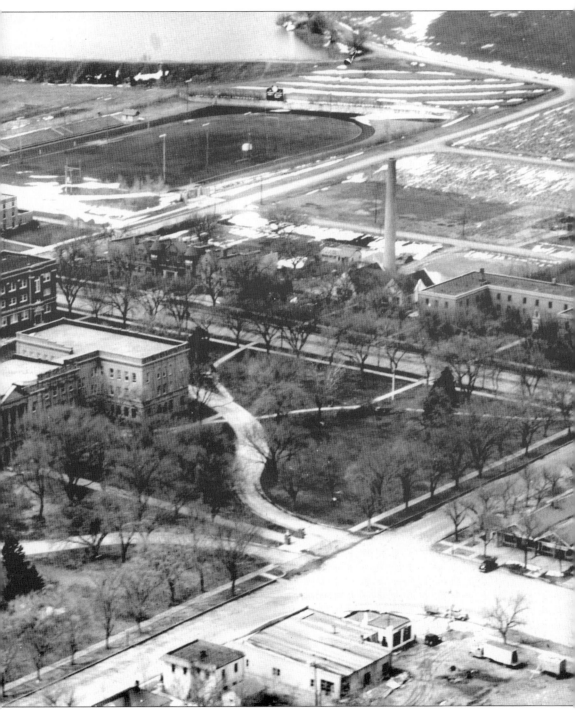

to the west side of the building in 1917. Sitting to the northwest of the administration building is modern-day Copeland Hall. Built in 1916–1917, Copeland Hall was home to the school gymnasium and pool. Beyond Copeland Hall on Twenty-sixth Street are Men's Hall, Green Terrace, Case Hall, and the football field. (Courtesy of the Calvin T. Ryan Library, University of Nebraska at Kearney.)

Green Terrace was built in the late 1880s during the Kearney boom. The building stood three stories high and faced the south, approximately where the former Ludden Hall sat before its demolition in February 2006. It was the primary residence for female students and served the campus until it was razed in 1959. (Courtesy of the Calvin T. Ryan Library, University of Nebraska at Kearney.)

While female students lived on campus at Green Terrace, there was no comparable facility for male students during the first 35 years of the college's existence. Male students were forced to board in town and on occasion, when housing was not available, lived in a "tent city" on campus. Finally in 1939, a residence hall for men, the aptly named Men's Hall, was completed. (Courtesy of the Calvin T. Ryan Library, University of Nebraska at Kearney.)

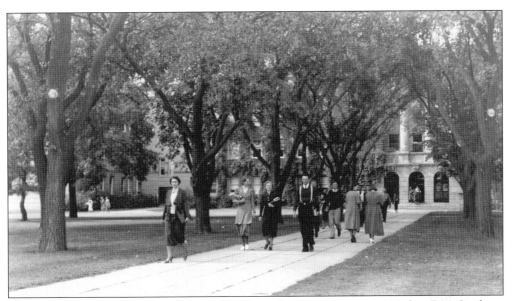

One of the annual events on campus was a tree-planting ceremony on Arbor Day. Students planted many of the trees that grew in front of the old administration building. Most of these beautiful trees were cut down when Founders Hall was erected in the 1970s. (Courtesy of the Calvin T. Ryan Library, University of Nebraska at Kearney.)

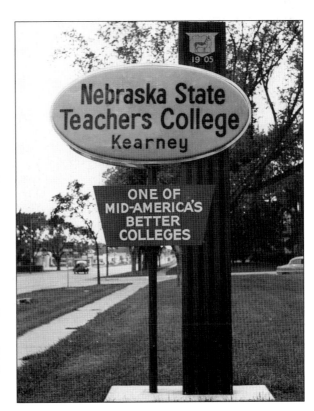

What is today the University of Nebraska at Kearney has gone through several name changes since it first opened for classes in 1905. It was originally called the Nebraska State Normal School, but when the school became a degree-granting college in 1921, the name was changed to Nebraska State Teachers College at Kearney. This name stuck for more than 60 years until October 18, 1963, when it was changed to Kearney State College. Finally, on July 1, 1991, the college merged with the University of Nebraska to become the University of Nebraska at Kearney. (Courtesy of the Calvin T. Ryan Library, University of Nebraska at Kearney.)

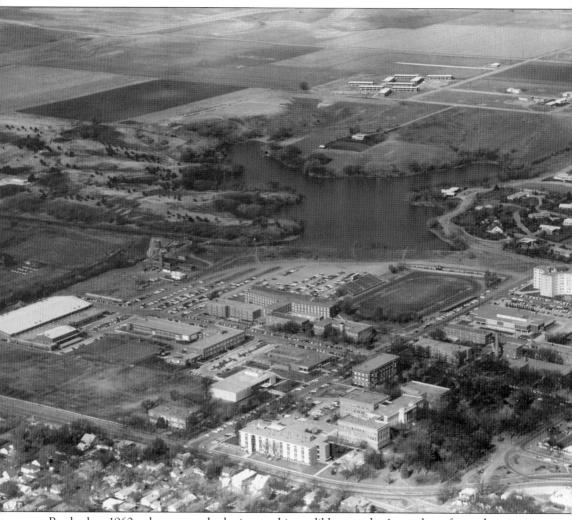

By the late 1960s, the campus had witnessed incredible growth. A number of new dormitories, including the Centennial Towers, dotted the campus. University Heights (housing for married students and graduate students) sits lonely on the plains above Kearney Lake.

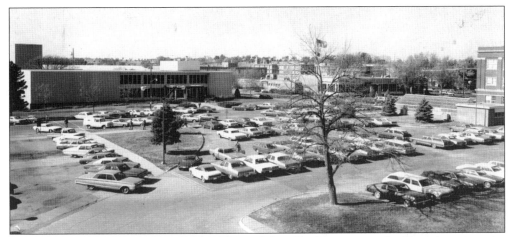

The first library was located on the third floor of the old administration building, but when the north wing was completed in 1911, the library was moved to the first floor of that new section of building. There the library remained until it was removed from the administration building to its new location in 1963. Known as the Calvin T. Ryan Library, it is seen here before the 1980s expansion. (Courtesy of the Calvin T. Ryan Library, University of Nebraska at Kearney.)

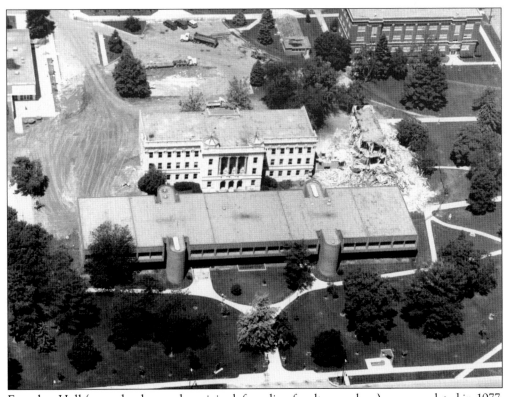

Founders Hall (named to honor the original, founding faculty members) was completed in 1977. The old administration building was demolished in several phases. Structural failures in the auditorium caused it to be razed in 1968. In this photograph, the north wing succumbs to the wrecking ball. The old administration building disappeared from the campus in 1984. (Courtesy of the Calvin T. Ryan Library, University of Nebraska at Kearney.)

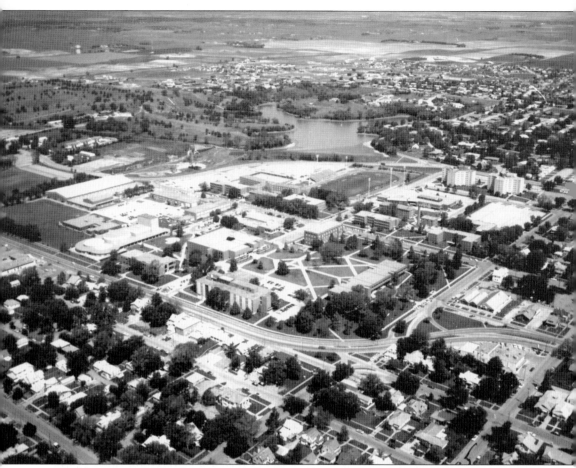

The University of Nebraska at Kearney boasts itself as a residential campus. With few exceptions, all freshmen are required to live on campus, and many upperclassmen live on campus during their entire tenure at the school. In 2006, over 2,500 students lived on campus in one of eight residence halls. Centennial Towers, the tallest structures on campus, were built between 1965 and 1967. They were named in honor of the 1967 centennial birthday of the state of Nebraska. During the winter of 2005–2006, Case and Ludden Halls were demolished to make room for three new residence halls. (Courtesy of the Calvin T. Ryan Library, University of Nebraska at Kearney.)

Six

WHERE THE
PEOPLE ROAM

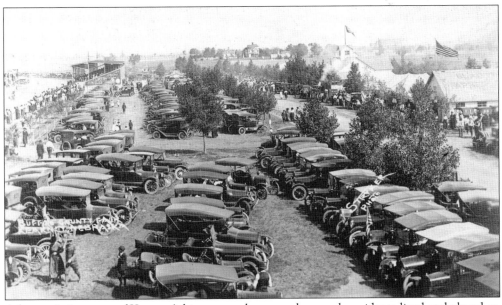

A humanistic aspect of Kearney's history can be seen where early residents lived and played or, more specifically, what was available for residences and recreation. Many subdivisions and parks have been added to the city over the decades. One staple of the past appears not in the form of a tangible place, but as an event. The Buffalo County Fair, pictured above in the early 1920s, began as an annual event in September 1881, in Shelton, as a form of promoting agricultural products and gathering the communities of the county together. Kearney hosted the fourth annual fair in 1884 on newly purchased fairgrounds on the northeast edge of town. Buildings from the grounds at Shelton were moved to the new site, and a new half-mile racetrack was built. The depression of the 1890s brought about a temporary halt to the Buffalo County Fair, but it was reorganized and held annually again in 1913 and has been held almost every year since.

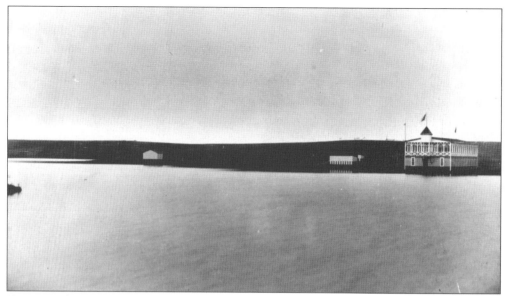

Kearney Lake originated as part of the canal system that tapped into the Platte River near Elm Creek. A series of lakes were filled (only Cottonmill and Kearney Lakes still exist), and the water was used to generate electrical power. On the south bank, an icehouse stood for many years. The ice was cut in the winter, packed in sawdust, and stored in the icehouse, providing Kearney residents with year-round ice.

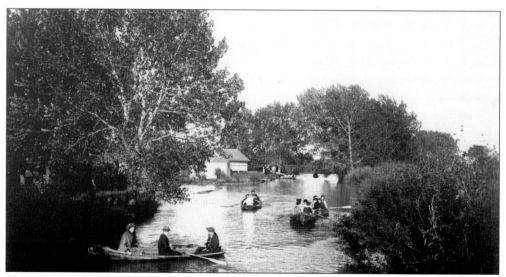

The Kearney Canal was once the site of much amusement and recreation. During warmer months the canal was full of boaters, while during the winter months the canal provided miles of ice for skaters.

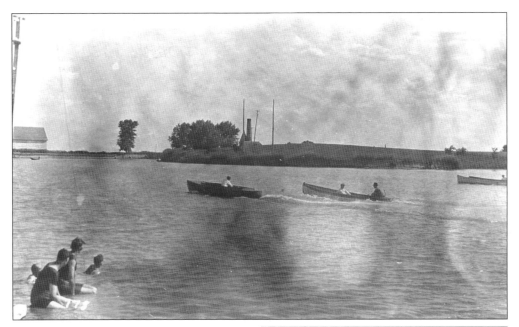

Kearney Lake was once the social center for Kearney. On the east banks stood a two-story pavilion that hosted dances and other summertime leisure activities. Rowboats could be rented, and a waterslide and diving platform added to the fun. During the 1890s, a flat-bottomed steamboat gave tours of the lake for a nominal fee. The lake is now almost entirely inaccessible to the public, as it has been surrounded by houses and the country club golf course.

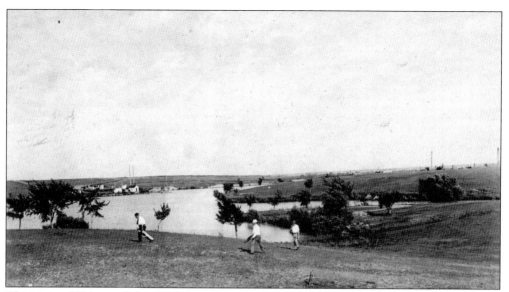

This view of Kearney Lake was taken from the country club's golf course on the west bank. Taken during the 1920s, it is still evident that the lake was being used for recreational purposes. Gone is the pavilion, but in the background is a waterslide and diving platform.

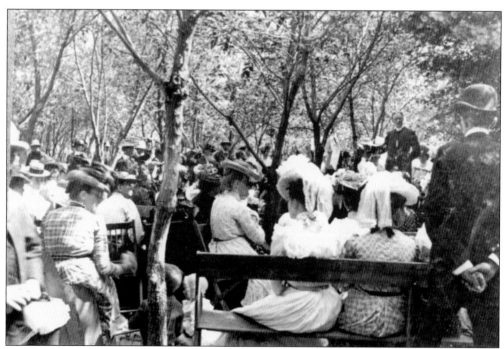

Tent chautauqua came to Kearney beginning around 1907. During the week the chautauqua was there, life virtually came to a standstill as the town focused on the speakers/reenactors. Thirty acres of land directly north of Third Ward Park (Harmon Park) served as Chautauqua Park from 1907 to 1924. Movies, radio, and air-conditioning decreased popularity for this art form, and the chautauqua circuit ended its performances in Kearney after 1928.

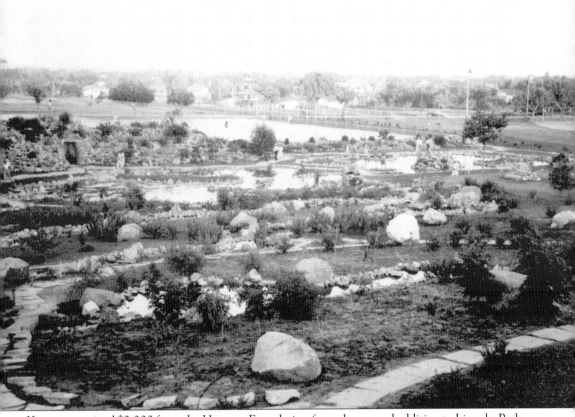

Kearney received $2,000 from the Harmon Foundation for a playground addition to Lincoln Park in 1924. Kearney was one of 50 lucky towns to be awarded money out of over 780 towns that applied. This addition, along with another half block purchased later by the city, comprises the six and a half square blocks called Harmon Park. A pool and bathhouse, as well as a rock garden, were built in 1937 with help from a grant by the Public Works Administration. The Works Progress Administration provided major funding for the garden, pictured here, which is said to contain a rock from every state and Kearney's first school, courthouse, and city hall. Horseshoe and tennis courts, recreational buildings, sidewalks, retaining walls, and other general improvements were completed with the help of this program. A "sonotorium," an outdoor performance stage, was built in 1938, and a lighthouse was added in 1940 as an overlook for the gardens. The park has remained virtually the same ever since.

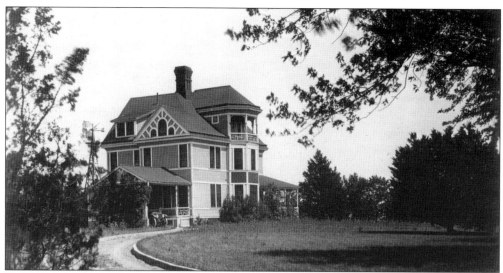

Nelson A. Baker, one of the managers of the Midway Land Company, built his house in the 1888 residential addition known as East Lawn. After 1,000 trees were planted, the subdivision was promoted as the best location for homes, especially with the electric streetcars running diagonally through the neighborhood via Grand Avenue. This street was designed to ensure everyone in the neighborhood had easy access to the boulevard.

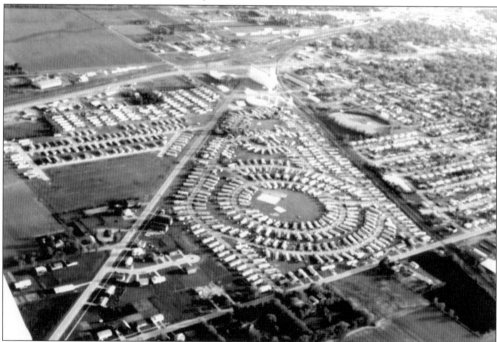

In 1889, the Midway Land Company contracted to build homes in East Lawn at a cost of $2,000 to $5,000. Due to the economic downturn in the early 1890s, however, the company built only 12 homes. While originally planned out as a prestigious neighborhood, economic trends in the 20th century caused changes in the subdivision. This aerial photograph shows the East Lawn Trailer Court that has replaced all of the original houses except that of Nelson A. Baker, located in the bottom center of the picture.

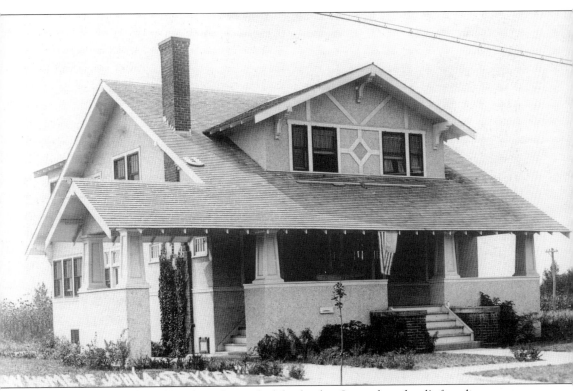

The houses around the college have been ideal for faculty. Since the school's founding, many students commuted to school, lived in campus housing, or lived in the private residences of family or friends. During the 1940s, small houses were built on Twenty-third Street as faculty housing. Over the last 40 years, many private homes have been turned into apartments and used as rentals to a growing number of college students living off campus. This house, once belonging to Prof. John Stryker and located across the street from campus, is currently divided into five apartments.

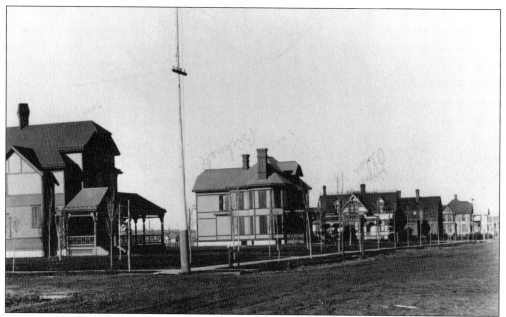

In 1889, 37 new houses were requested to be built in one of Kearney's newest residential additions, known as Kenwood, located on Eighth Avenue. The layout and improvements were done by the Kearney Land and Investment Company. Advertising for the area stressed the fine quality of the houses, all costing over $2,000, good streets and walks, lights, gas, telephone service, city water, and access to electric streetcars.

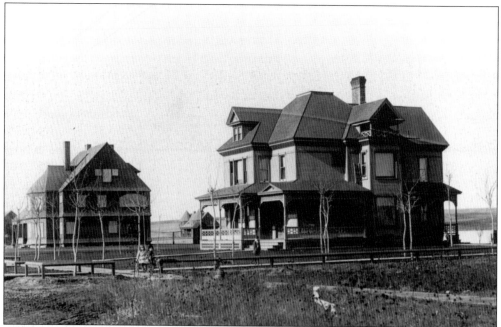

Development of West Kearney (including the Kenwood neighborhood) started during the boom period around 1889. With the completion of the Kearney Canal, businesses, industry, and homes had access to electricity. During 1889, the population of Kearney increased by 3,000 persons (12,000 inhabitants by the end of the year), and almost 500 new residences were built.

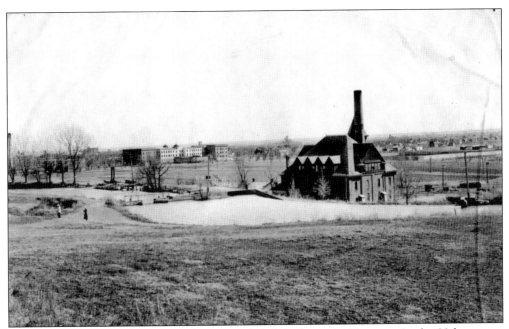

Three small lakes once completed the geography of northwestern Kearney. As the 20th century wore on, two lakes were filled in to make room for more housing. Kearney Country Club was ideally located next to Kearney Lake and the powerhouse on the west edge of town. Pictured above in the 1920s, the course had a good view of the few buildings that made up the normal school.

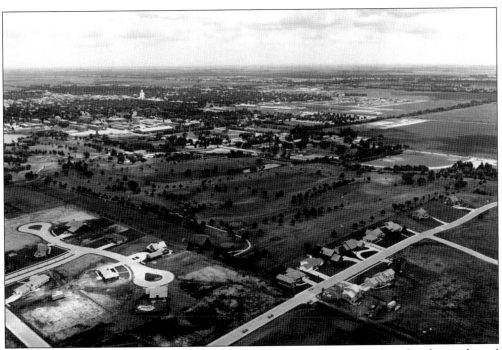

This aerial shot from 1984 shows the expansion of not only the college but also the residential sections of town that grew up around the country club's golf course. Most of these houses were built after 1980, and the area is considered to be one of Kearney's more prestigious neighborhoods.

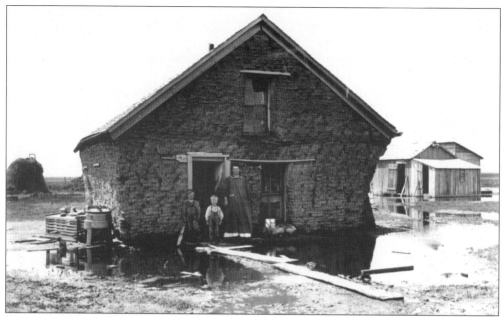

The first settlers to the treeless and wind-blown prairie did not have ready access to lumber. Even after the railroad was established, most new settlers to the area in the 1800s did not have the financial means to build houses from lumber. Sod houses became the most practical building style for new arrivals. "Soddies" had walls over a foot thick, which allowed them to stay cooler in summer and retain heat during winter.

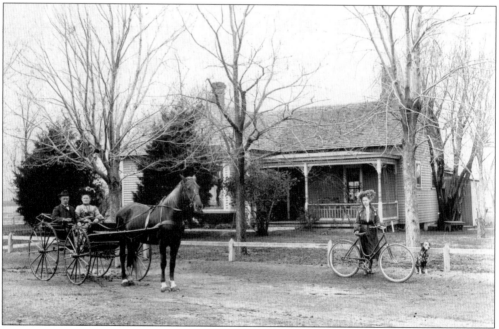

As Kearney's economy grew in the latter years of the 1800s, so too did its access to affordable lumber. While some soddies were used on farmsteads into the 20th century, houses in town were constructed with wood. Trees were planted with each new house as a means of shade and windbreak.

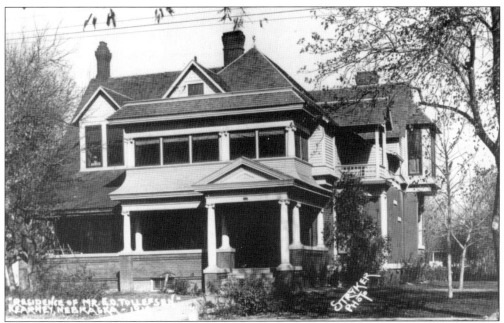

Many larger homes from Kearney's early days still stand in the original residential sectors of town, such as this one on Twenty-seventh Street. In the neighborhood south of the college, where rentals and private homes exist side by side, a Walk of Houses was created to tour the area in an effort to bring the history of the neighborhood to the public. A number of homeowners have made efforts to restore their houses to their original appearances.

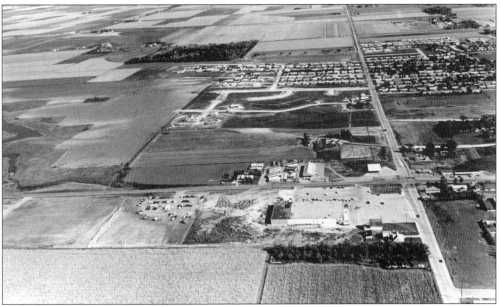

Kearney has grown significantly on the north side of town. This photograph of the intersection at Thirty-ninth Street and Second Avenue looking east, taken in 1970, shows streets being created for the new Indian Hills subdivision, the most northern area in town at the time. Today businesses, retail stores, and restaurants along Second Avenue extend the city more than a mile to the north, while residential neighborhoods have expanded north and outward behind them.

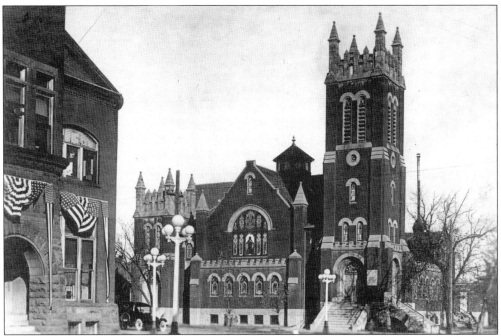

In 1872, the Methodists were the first denomination to organize a congregation in Kearney Junction. They built a church in 1874 that was shared with other denominations. This 1920s photograph shows the Methodist church situated on the northeastern corner of Twenty-second Street and Avenue A. The church was destroyed by a raging fire on Christmas day in 1969. The Kearney Fire Department is now located at this site.

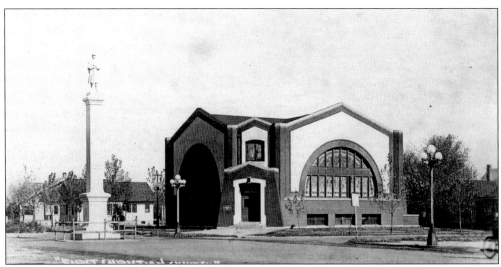

One of the early churches in Kearney was the Christian church. The original Christian Church, organized in 1874, erected a building at Twenty-fifth Street and Avenue C in 1889. It later served as the Zion Lutheran Church from 1914 to 1951. This 1920s photograph shows the next location of the First Christian Church on the main intersection of Twenty-fifth Street and Central Avenue.

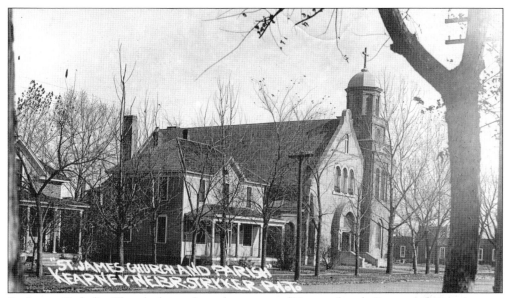

St. James Catholic Church, located on the corner of Twenty-fourth Street and First Avenue, was used by the Catholic Church after the building was vacated by Presbyterians in 1905. The church and rectory, photographed here around 1920, was built on the site of the old building in 1910. A new St. James Catholic Church was built in 1980 farther north on Avenue A next to the Kearney Catholic High School.

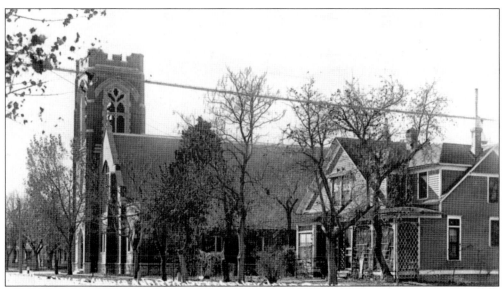

Organized in 1882 as the Episcopal Church of the Good Shepherd, the church changed its name to St. Luke's in 1888. St. Luke's Episcopal Church was built on Second Avenue in 1908 and is the last downtown church to remain active.

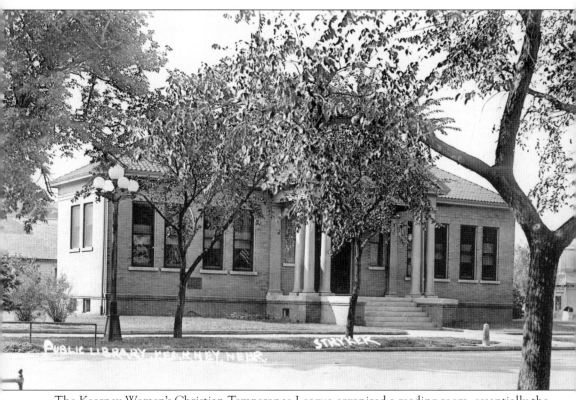

The Kearney Women's Christian Temperance League organized a reading room, essentially the first public library in town, where readers could borrow books and old magazines for 5¢ each or be lifetime members for $5. William Skinner opened the first Kearney Library in 1889 at a house on Twenty-fifth Street and First Avenue. The library moved to the city hall in 1890, then in 1904 to a building on Twenty-first and First Avenue funded by the Carnegie Foundation, pictured here around 1920. In 1973, this building was razed, and a larger building constructed on the site was opened in 1975.

Seven

SERVING THE MILITARY

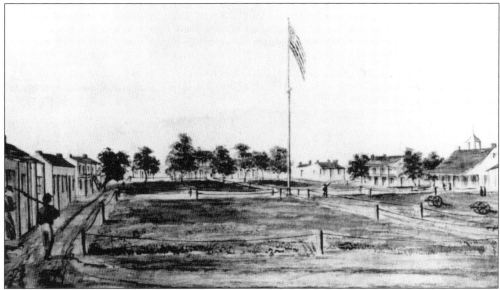

Fort Kearny is situated about six miles southeast of the city of Kearney on the south bank of the Platte River. Named after Col. Stephen Watts Kearny, Fort Kearny was first established along the Missouri River in 1846 but was moved westward to its present location in 1848 to be closer to the overland trails. From 1848 to 1871, the fort served and protected emigrants on the Oregon and Mormon Trails. With the completion of the transcontinental railroad in 1869, and diminishing overland wagon traffic, the fort was abandoned in 1871. In 1929, the land was turned over to the state, and Fort Kearny became a state park.

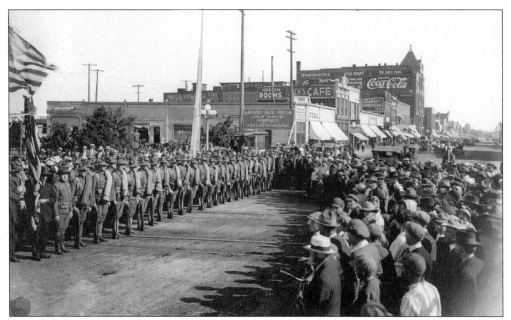

Over 800 Buffalo County men served in World War I and at least 22 area residents lost their lives during the conflict. One of those casualties was the well-liked Rev. W. H. J. Willby. Prior to enlisting he had been a pastor at the Congregational church and the headmaster of the Kearney Boy Scouts. Pictured below are 50 draftees posing on the steps of the Buffalo County Courthouse. In the photograph above, a crowd sends a company of soldiers off to war.

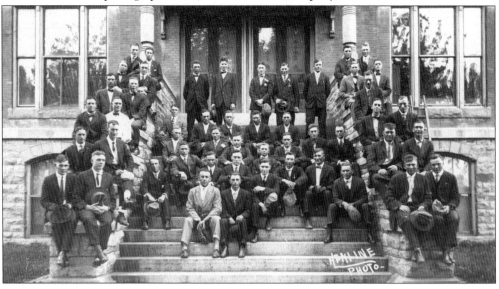

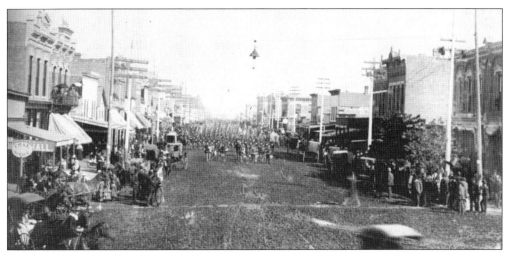

In September 1888, Kearney hosted the Nebraska Grand Army of the Republic reunion (a Civil War veterans organization). Between 40,000 and 45,000 people attended the event. With all the hotels full, the city put up several tent cities around Lake Kearney. The reunion witnessed three parades, the largest having 6,000 people and 22 bands. The festivities were concluded with a rendition of the famous Civil War naval battle between the *Monitor* and the *Merrimack*. Two steamboats were converted into warships, and a reported 25,000 people circled Lake Kearney for the spectacle.

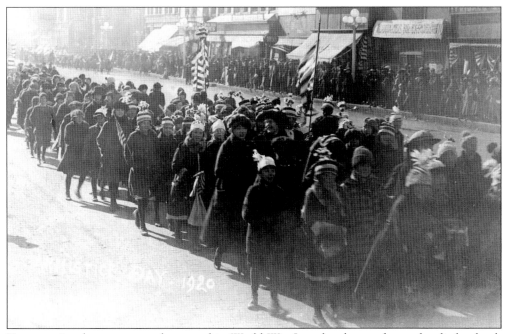

To recognize the area men who served in World War I, and to honor those who died, a book titled *In the World War, Buffalo County, Nebraska* was published in 1919. The book listed the name, rank, and service history of each Buffalo County serviceman. The book also included photographs of over 700 soldiers and sailors. In the photograph above, children march in an Armistice Day parade on Central Avenue in 1920.

The Kearney Military Academy, located in the East Lawn area, was founded in 1891 by the Episcopal Church. Originally called the Platte Collegiate Institute, the academy was a coeducational school until 1898 when Rev. E. P. Chittenden converted the school into a military preparatory school. The academy had a large student body in the years between the Spanish-American War and World War I. During the 1920s, however, financial problems and dwindling enrollment in the wake of World War I forced the academy to close its doors. The buildings were vacant for many years. During World War II the old academy temporarily housed German prisoners of war. Today the remaining building is part of St. Luke's Good Samaritan Village.

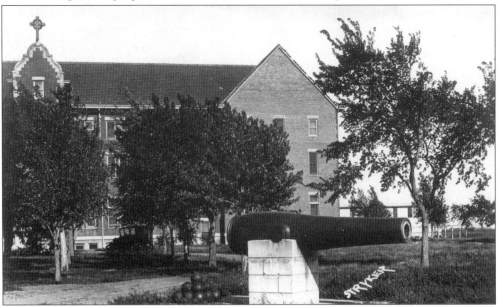

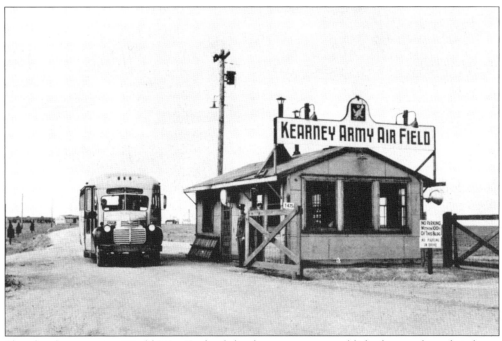

Shortly after entering World War II, the federal government established a number of air bases and munitions plants in Nebraska. The city of Kearney was awarded an air base after it offered its newly completed municipal airport, Keens Field. Construction on the air base began in September 1942, and by November, over 3,000 laborers were working on the runways, hangars, and barracks. When the base began functioning in January 1943, it was said to be a "complete city within its own area." Base facilities included a post office, theater, hospital, chapel, recreation hall, and post exchange.

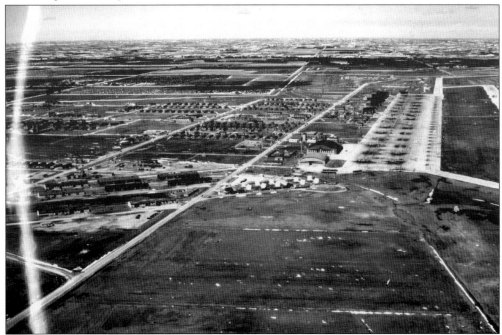

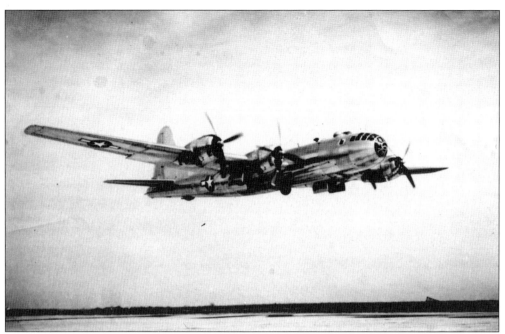

The Kearney Army Air Field saw a wide range of aircraft during its lifetime. The first B-17s arrived on February 4, 1943. In the spring of 1943, the base served as the training facility for the 100th Bombardment Group, which was responsible for producing new Army Air Corps groups. Many of those who trained at Kearney filled out the 8th Air Force in Europe. Beginning in 1944, the base began processing B-29 Superfortress crews (pictured above) for service in the Pacific Theater. During the first five months of 1945, the base processed 554 B-29 crews. After the war, the fighter wing of the 8th Air Force was stationed at Kearney. P-51 Mustangs, pictured below, were the primary airplane in the fighter wing.

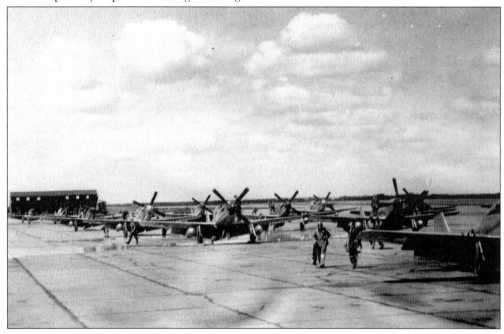

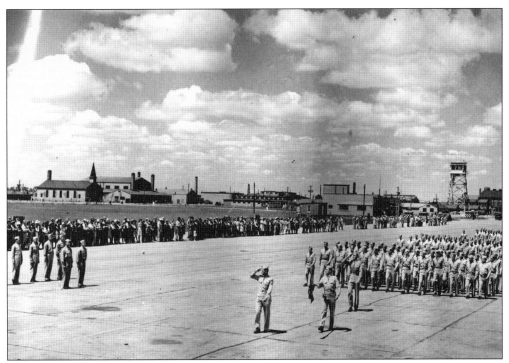

The air base was capable of processing 388 B-17 crews a month by 1944. By May 1945, B-29 crews spent an average of 9.3 days on base while being processed.

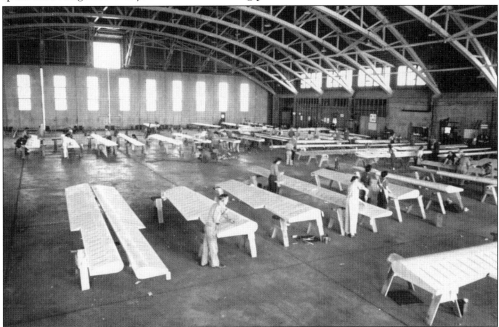

The air base could not have functioned without the work of local civilians. Approximately 800 civilians worked in a wide variety of occupations. Carpenters, machinists, electricians, welders, and blacksmiths all found work at the base. Women comprised a significant portion of the civilian workforce. Women repair airplane wings with hail damage in this photograph.

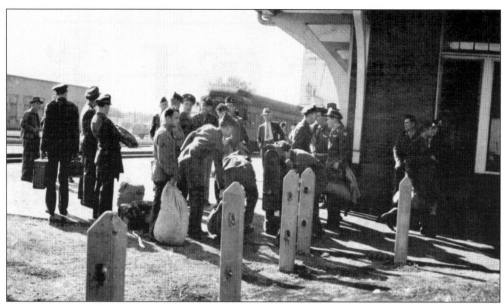

Troops began arriving at the Union Pacific Railroad depot in late January 1943. The base served both as a training center for bomber crews and a processing center where crews did their final checks before being assigned to a combat zone. Later in the war, the base was used to train replacement crews. Perhaps the most famous airman who trained at Kearney was movie star Clark Gable. In this photograph, soldiers gather their belongings at the Union Pacific Railroad depot before being bused to the base.

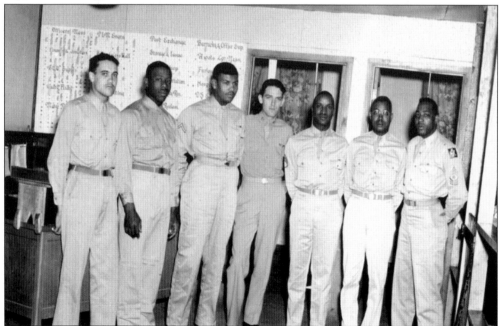

During World War II, the military, like most of society in the 1940s, was still racially segregated. African American soldiers and their families had segregated living quarters and recreation facilities. The Windsor Hotel in downtown Kearney provided housing for black families, and the recreation facilities at the 1733 Park were reserved for black soldiers.

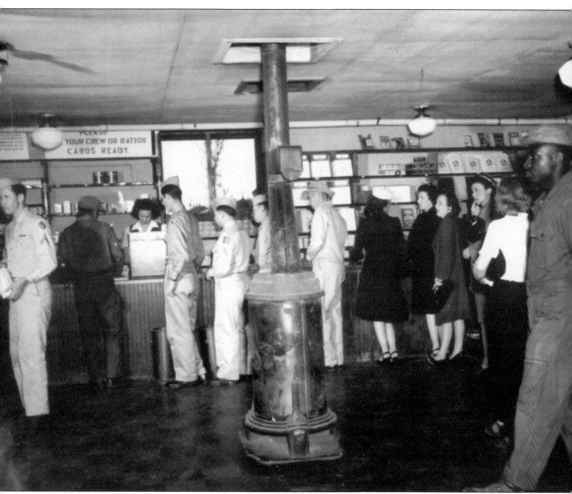

During its peak, the base was a mini-city. It had facilities for entertainment, religion, and recreation. The base chapel, which witnessed hundreds of weddings during the war, was designed as a multidenominational facility. This photograph reflects the diverse population at the base. Military and civilians mix together at the post exchange as do black and white soldiers.

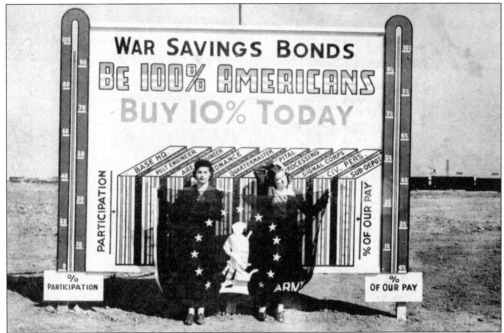

World War II could not have been financed without the American public's financial assistance. By the end of the war, more than $150 billion had been raised through the sale of war bonds. This photograph depicts a bond-buying competition among different air base departments that was organized by the Civilian Welfare Association.

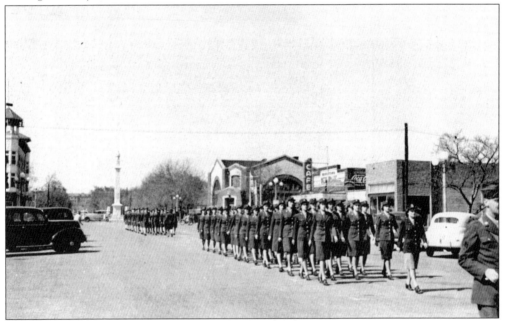

More than 150,000 American women served in the army during World War II. Known as Women's Army Corp (WAC), they served in noncombatant military positions. On June 21, 1943, the first unit of WACs arrived at the base. The base had accommodations at the base for 132 WACs. In this photograph, a company of WACs march in a parade down Central Avenue.

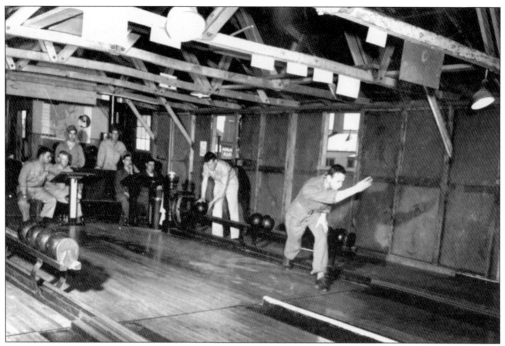

The air base had an array of recreational and entertainment facilities. Lounges for officers and enlisted men provided a place to relax. In their free time, soldiers took advantage of the base bowling alley, theater, and sports fields. The base fielded several sports teams that competed against other Nebraska bases and local teams. An air base football team, led by Victor Spadaccini, a former All-American out of the University of Minnesota, played against several other base teams.

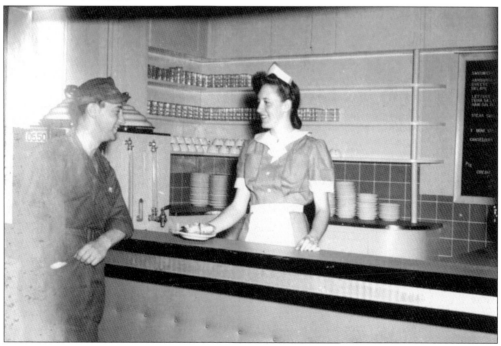

The United Service Organizations (USO) provided entertainment for soldiers during World War II. To assist the USO, the city created the Kearney Recreation Committee. More than $10,000 was raised to open a hospitality center for arriving soldiers. A vacant building at 2007 Central Avenue was selected, and the center opened on January 15, 1943. The center included pool and Ping-Pong tables, a jukebox, a dance floor, and a snack bar. A separate facility at 2220 Avenue A was opened for African American troops.

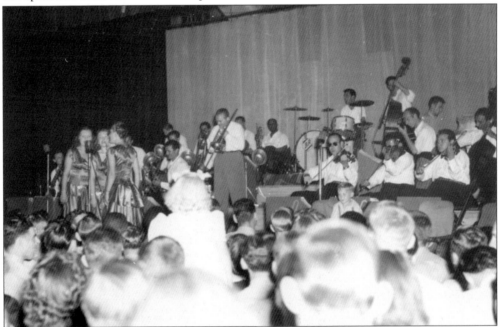

A number of famous musicians, including Duke Ellington, Louis Prima, the King Cole Trio, and Tommy Dorsey, performed for servicemen. Local girls who served in the USO hostess corps were bused to the base to provide company and dance partners for the soldiers. Tommy Dorsey's band performs in the photograph above.

Eight

REMEMBERING KEARNEY

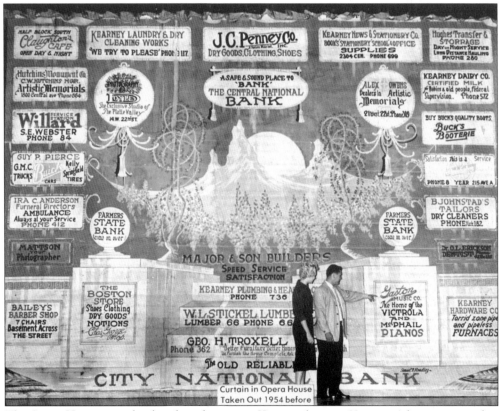

The Opera House was a landmark in downtown Kearney for over 60 years. After it was razed in 1954, the curtain was saved. In 2006, the curtain and three faces that decorated the doorway, carved from large stone blocks, are on display at Trails and Rails Museum, part of the Buffalo County Historical Society.

On April 11, 1871, D. N. Smith, Rev. Asbury Collins, and Moses Sydenham chose the site for Kearney Junction. Collins and his wife, Louisa, pictured above, along with their family, were the first to settle in the new town. The couple was active in the promotion and establishment of the town. Asbury was the town's first postmaster, and Louisa is remembered as the "mother of Kearney."

Samuel Clay Bassett came to Nebraska in 1871 with his wife and two children and took a soldier's homestead claim in Buffalo County. He was a schoolteacher, school board member, state legislator, vice president of the Nebraska State Historical Society, and author of *History of Buffalo County Nebraska*, which spotlights not only key events of the first 50 years of the county but also biographies of influential people.

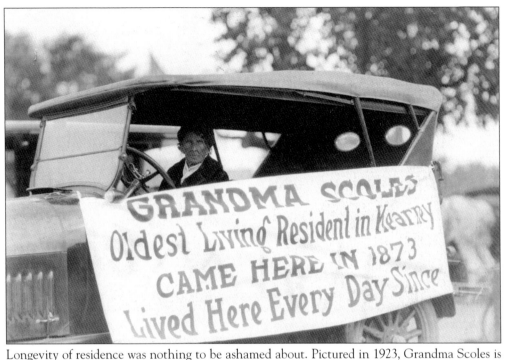

Longevity of residence was nothing to be ashamed about. Pictured in 1923, Grandma Scoles is heralded as the "oldest living resident in Kearney" after coming to the town in 1873.

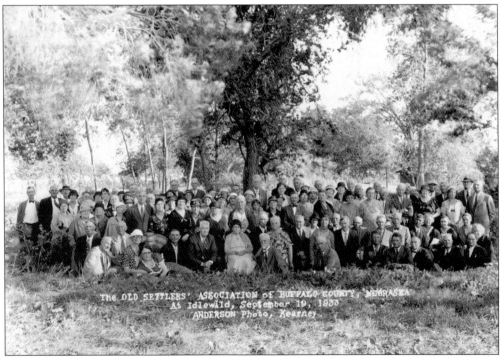

The Old Settlers' Association of Buffalo County met periodically to share memories of days past. Here the group meets at Idlewild on September 19, 1933.

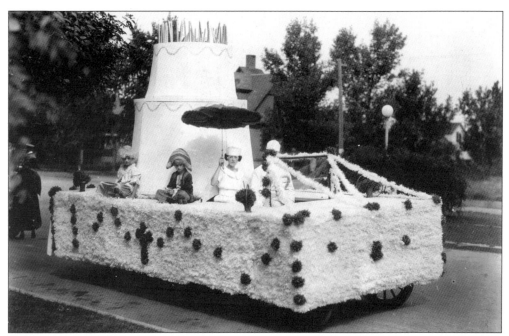

Residents from Kearney have taken pride in the permanence of the town for over a century. For the 50th anniversary in 1923, the town planned a three-day celebration, complete with a parade down Central Avenue. This official 50th anniversary cake float was sponsored by the Weaver Bakery.

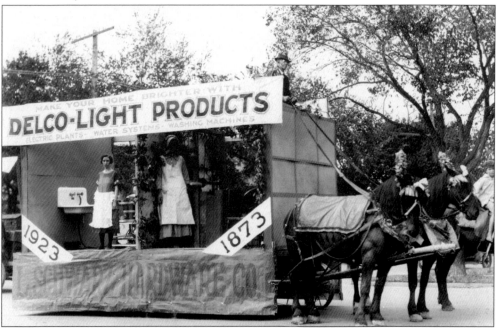

The L. Schwarz Hardware Company float shows the underlying theme of the 50th anniversary parade, comparing "old" Kearney in 1873, with no electricity, and "new" Kearney in 1923, full of modern conveniences. Ironically, the floats themselves bridged two eras; many were pulled on wagons by horses, while others were built with motorcars.

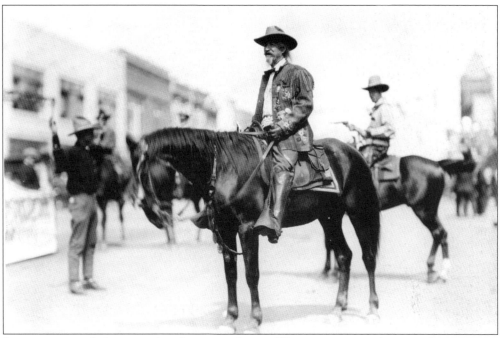

Letters were mailed to countless former residents of Kearney inviting them to a homecoming to be celebrated through the 50th anniversary of the town. Replies came in the form of postcards and letters, some of which were long accounts from early settlers. Quotations from these replies were printed in local newspapers. Festivities for the 50th anniversary kicked off on September 12, 1923, with a barbecue of 1,200 pounds of baby beef and a campfire. The next day, Kearney residents watched a parade, Native American show, and circus, while on the third day the population was treated to a downtown fashion show and fireworks that night. An estimated 15,000 people attended.

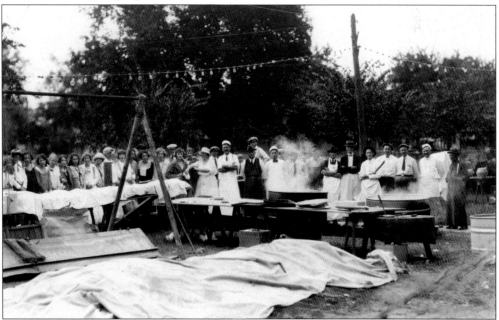

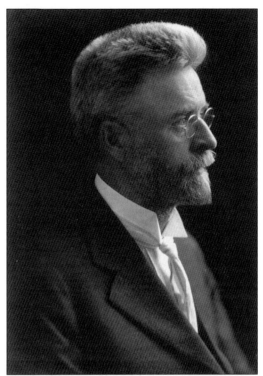

Alfred T. Anderson came to Kearney in 1875 at the age of 10. After completing public school, he learned photography while working at J. A. Stridborg's gallery, located south of the railroad tracks on Central Avenue, and took over the business. While he took countless studio portraits, his most lasting images are of Kearney during the 1880s–1890s, including this image of the Kearney Power House. His photographs of businesses, houses, and downtown are located in businesses today all around town.

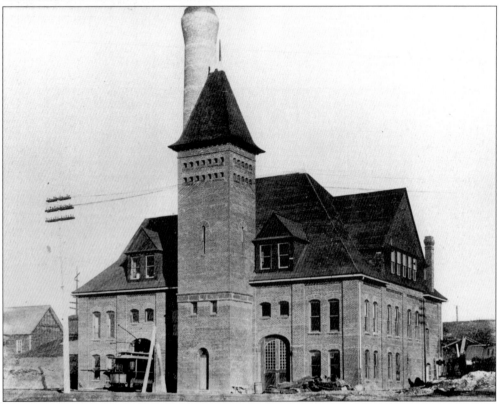

John Stryker was hired as the normal school's first instructor of penmanship in 1909. He was quite a character and in 1916, after acquiring a Kodak camera, became fascinated with photography. He resigned at the school in 1919 to pursue photography. Although he only spent a few more years in Kearney, his shots of the college, downtown, rodeos, and fairs are one of Kearney's best links to the second and third decades of the 20th century. Stryker enjoyed action shots and aerial views. One of his most widely known photographs is this one taken at the 1919 Kearney Roundup.

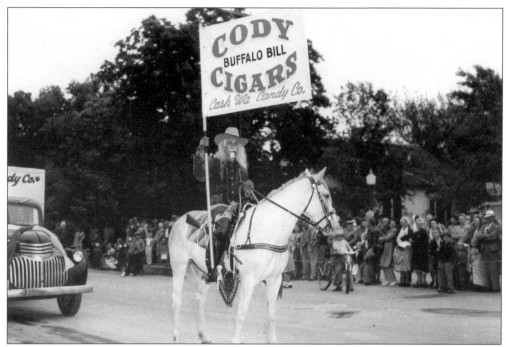

Kearney's 75th anniversary was known as the Diamond Jubilee in 1948. Men were required to wear beards or mustaches, and those who did not were either dunked in a horse tank or sent to face a kangaroo court. A whisker contest was judged by local barbers.

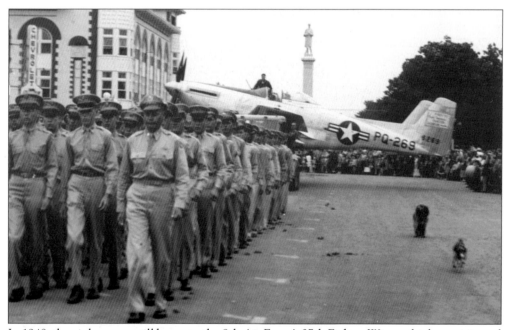

In 1948, the air base was still home to the 8th Air Force's 27th Fighter Wing, which participated in the jubilee parade. Festivities also included a free street dance, crowning of a jubilee queen, luncheon with guest speaker Gov. Val Peterson, and three nights of a "cavalcade of Kearney" that featured street scenes, square dancing, and horses from Kearney and surrounding towns.

The businesses and buildings of downtown have come and gone over the last century; however, one staple remains: the brick streets. The streets, paved in brick in 1915–1916, remain that way in 2006. Recent advertisements have nicknamed the downtown shopping center as "the bricks" to associate that aspect of history with economy. Here MONA displays historic and modern art in the historic post office building.

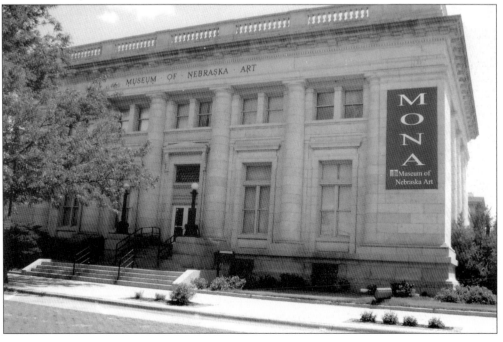

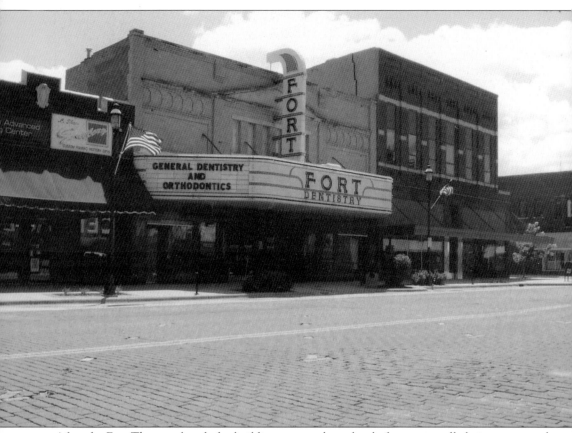

After the Fort Theatre closed, the building was used as a bar before eventually being converted to a dentist's office. Although the businesses have changed, the outside has remained about the same. However, many buildings downtown have changed considerably during the last 130 years. In an attempt to return some of the character of Central Avenue, in 2006 a competition was held that awarded a grant of $30,000 to a downtown business that remodeled the outside of its building to look how it was during an earlier era.

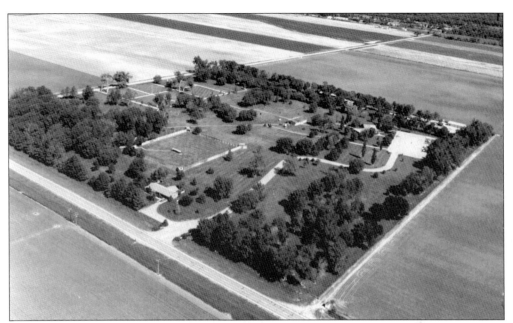

Fort Kearny operated as a military post along major trails to western states from 1848 to 1871. With the completion of the transcontinental railroad in 1869, the fort's role as protector of trails became obsolete as overland travel waned. The land was sold to settlers, including William O'Dungan, who encouraged reunions of military veterans, illustrating reverence for the landmark's history. Fort Kearny has been a state park since 1929.

Spanning Interstate 80 just east of Kearney, the Great Platte River Road Archway Monument celebrates the history of the Platte River valley as a transportation route across the continent. From the Oregon and Mormon Trails to the Lincoln Highway and Interstate 80, the archway provides an interactive history lesson to visitors. The archway, which opened in 2000, was envisioned by the late Nebraska governor Frank Morrison. (Courtesy of the Great Platte River Road Archway Monument and J. Nabb.).

Land for Buffalo County's new historical society museum, named the Trails and Rails Museum, was donated in 1975 on the southern edge of Kearney in the midst of farm fields. The four officers of the historical society were not only instrumental in getting the museum started but also very involved in trying to make the history they preserved accessible to the public. Pictured in this photograph are, from left to right, Jack Cary, Paul Farm, Alice Howell, and Philip Holmgren. The depot, which was carried over from the town of Shelton on a truck, was the first addition to the grounds in 1975. Built in 1903, the Baldwin engine No. 481 was brought to the site in 1977, followed by the flatcar and caboose by 1979. This aerial photograph was taken of the grounds in August 1979.

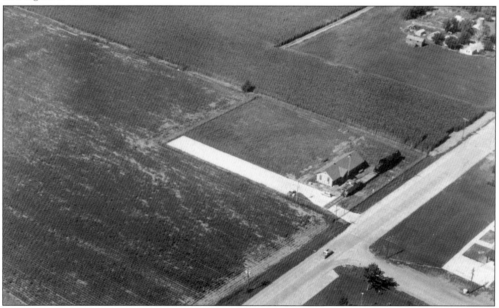

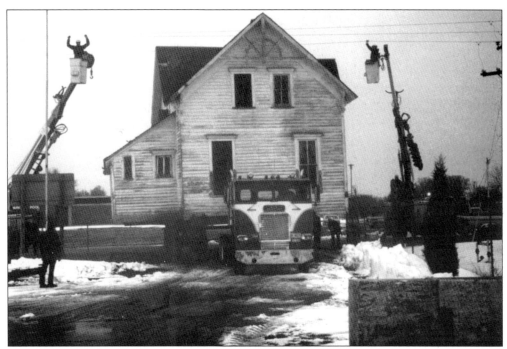

The Freighter's Hotel was moved onto the Trails and Rails Museum site in January 1983. The hotel was built in 1884 and located along the freighting trail between Kearney and Broken Bow as a resting point before the railroad built a branch line connecting the two towns. All historic buildings, including the train and caboose, were brought to the museum by semitrucks.

Artifacts from across the county are on display at the Trails and Rails Museum. Here a freighter's wagon from Fort Kearny is being unloaded in June 1985. In the background is the first frame schoolhouse in Buffalo County, built in 1871.

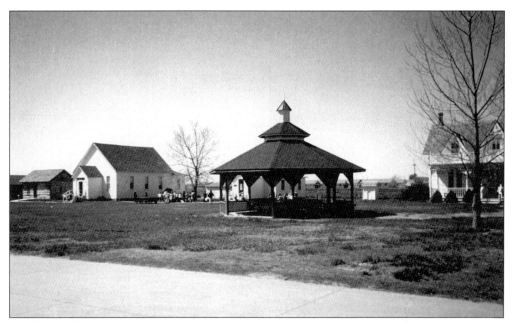

The gazebo was the second structure built at the Trails and Rails Museum. The first was the archives building that houses original documents and records the courthouse has copied onto microfilm. The rest of the buildings were brought in from across the county. Seen here are, from left to right, Egger's log cabin, the German Baptist church, the schoolhouse, and the Freighter's Hotel.

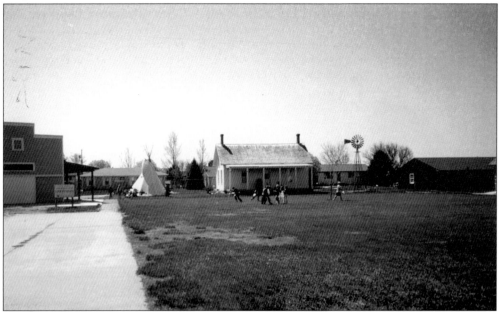

In 2006, a residential neighborhood surrounds the Trials and Rails Museum site as Kearney continues to expand in all directions. The museum has also grown to include a livery barn (located at left), constructed in 2005 and 2006 to house wagons, a fuel cart, sleigh, mail cart, and fire wagon. Contrasting the modern homes in the background are a teepee, the Boyd Ranch House, a windmill, and the archives building.

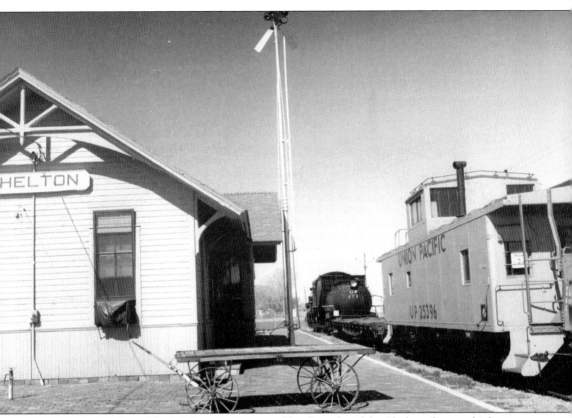

Visitors to the Trails and Rails Museum are greeted by the sight of the Shelton depot, which was built in 1898, next to the caboose, flatcar, and engine donated by the Union Pacific Railroad. Not only does the historical society and museum house the history of the county, but the buildings and houses themselves offer a unique living history.

ACROSS AMERICA, PEOPLE ARE DISCOVERING
SOMETHING WONDERFUL. THEIR HERITAGE.

Arcadia Publishing is the leading local history publisher in the United States. With more than 3,000 titles in print and hundreds of new titles released every year, Arcadia has extensive specialized experience chronicling the history of communities and celebrating America's hidden stories, bringing to life the people, places, and events from the past. To discover the history of other communities across the nation, please visit:

www.arcadiapublishing.com

Customized search tools allow you to find regional history books about the town where you grew up, the cities where your friends and family live, the town where your parents met, or even that retirement spot you've been dreaming about.